D0567750

Art Education and
Human Development

HOWARD GARDNER

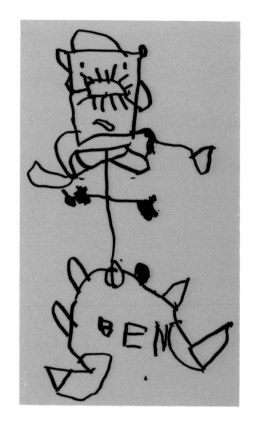

"Shredder"
(A bad guy on a TV Show)
Benjamin Gardner, Age 4
December 1989

Art Education and Human Development

Howard Gardner

Professor of Education

Harvard Project Zero
Harvard Graduate School of Education and
The Boston Veterans Administration Medical Center

Occasional Paper 3

The J. Paul Getty Museum
Los Angeles

©1990 J. Paul Getty Trust. All rights reserved.

Getty Publications
1200 Getty Center Drive, Suite 500
Los Angeles, California 90049-1682
www.getty.edu/publications

Editor: Nicky Leach

Designer: Kurt Hauser

Printed in the United States of America

Eighth printing

ISBN 978-0-89236-179-3

Library of Congress Cataloging-in-Publication Data

Gardner, Howard.
 Art education and human development : an essay commissioned by the
J. Paul Getty Center for Education in the Arts / by Howard Gardner.
 p. cm.—(Occasional paper series ; v. 3)
 Includes bibliographical references.
 1. Art—Study and teaching (Elementary) 2. Educational
psychology. I. Getty Center for Education in the Arts. II. Title.
III. Series: Occasional paper (Getty Center for Education in the
Arts) : 3.
 N350.G37 1990 90-2955
 707—dc20 CIP

Contents

he Getty Center for Education in the Arts is gratified once again to sponsor an opportunity for eminent scholars and practitioners in art education and related fields to articulate ideas that enlighten and inform our understanding of art education and human development.

We are pleased to present the third paper in our Occasional Papers series by the distinguished cognitive psychologist, Dr. Howard Gardner. Professor Gardner has made significant contributions to the fields of cognitive development and art education for more than twenty years, and the Center is happy to present *Art Education and Human Development* as an extension of his continuing work in these areas.

It is our hope that the Occasional Papers will add to the appreciation of art and its significance in our lives. Dr. Gardner's thoughts are substantive, insightful, and reflective; they form an important contribution to this series.

Leilani Lattin Duke

Director

Getty Center for Education in the Arts

Summer 1990

All discussions of educational issues entail considerations of values, and this truism has been embodied in the often controversial domain of art education. Plato viewed education in the arts as dangerous to the social fabric of society; religious and political leaders provided (and occasionally withdrew) support for the ateliers of the most gifted artists during the Renaissance; totalitarian governments in the twentieth century immediately insert themselves into the arts classroom; and even in democratic societies, there are heated and unresolved debates about whether public funds should be used to support art schools, particularly if some of the students produce works which offend the social or political mores of segments of the community.

In most cases, the values and priorities of a culture can be readily discerned in the way in which its classroom learning is organized. If one ventures into the art class in an elementary school anywhere in contemporary China, one sees youngsters bent over their desks producing paintings and drawings in a classical ink-and-brush style, in much the same manner that this approach has been inculcated over the centuries. Models of the "correct schema" are posted around the room and in the textbook; the teacher himself will have produced a "textbook" version of the desired "end product" on the front wall; and students will work assiduously until "their" version has become virtually indistinguishable from the others on display. There is little opportunity (and, apparently, little desire) to fashion works in an alternative style, and no trace of abstract designs, which are generally forbidden. Nor is there any discussion of the history, meaning, or purpose of these works, in times past or in the contemporary era. As in many other traditional cultures, art classes in China are dedicated to the transmission of the skills needed to produce exemplars of the most valued works and genres from the past (Gardner, 1989a,b). (For an intriguing exception see Ho, 1989.)

Educational policy in the United States is set at the local level, and so it is less feasible to anticipate what will be observed in different schools, even when they are located in nearby communities (Jones, 1989; National Endowment for the Arts, 1988; Stake, 1989). Still, some generalizations are relatively feasible.

During the early years of schooling, students have considerable latitude with respect to what they may do when given a surface on which to make marks. Only infrequently is an adult model's work on display; and only rarely does the child's own teacher provide that model. Instead, consistent with a progressive ethos which continues to hold sway in the arts, young children are simply provided with lots of inviting materials and encouraged to draw or craft whatever they like. The resulting collection of works is often technically of indifferent quality, but, in contrast with China, there will be a wider range, including at least some works that are abstract in flavor and some works that stand out for imaginative flavor or idiosyncratic originality. Children may be encouraged to talk about their own feelings or purposes in creating a particular work, but, for the most part, there is unlikely to be discussion of historical or aesthetic matters. At older ages, art classes wane in frequency, except for those youngsters who have special interest in, or aptitude for, the arts. Even in these latter cases, the emphasis falls very much on artistic production: historical, reflective, or aesthetic issues have seldom figured as a significant component of American precollegiate education in the visual arts.

In the light of such contrasting vignettes, it is relatively straightforward to surmise the different attitudes that dominate visual arts education in the two countries. In China, it is assumed that cultivation of the "best" from the past is the principal goal of art education; children have the potential to become participants in a venerable tradition. Indeed, the goal of education in the schools is to enlist children in these practices as early and as readily as possible. Talk about art and exposure to alien art practices are not (and never have been) considered a priority. In contrast, in the United States, study of the artistic practices of the past has not been considered relevant to youthful production, and such activity has been infrequent even during secondary education. Nor have technical skills in rendering been deemed a priority. Instead, like other art forms, the visual arts are thought to provide opportunities for younger children to explore media, to invent their own forms, and to express ideas and feelings that they deem important. As older students become interested in representing reality with accuracy, they may well be introduced to suitable techniques (or discover them even without explicit tutelage). But except for those who choose to

become involved in visual arts in a vocational or a seriously avocational way, little effort is made to inculcate technical facility, to teach youngsters how to render "beautiful" works, or to familiarize students with traditional approaches, values, or historical considerations in the visual arts. Whether, in the wake of recent initiatives, this picture will change, it is too early to tell.

As one surveys regimens of art education around the world, one encounters a variety of educational stances and procedures, reflecting the range of historical factors and value considerations at work in diverse cultures (Ott and Hurwitz, 1984). Indeed, given the dramatically different conceptions of aesthetics in different cultures, this diversity seems more likely to occur in the visual arts than in, say, mathematics or foreign language instruction. But from a scientific perspective, it is appropriate to ask whether the approaches and practices in art education are (or could be) infinitely varied; or whether, instead, the principles that govern human development place meaningful strictures on the course of art education: on what can be taught, on how it can be taught, and on what the educational outcomes can be. While the answer to this research question is exceedingly difficult to determine and cannot in itself dictate the optimal course for art education, an examination of scientific findings about human development can help to delineate the options from among which arts educators can make informed choices.

In this essay, I survey what psychologists have discovered in past decades about the principles that govern the development of human beings. A special focus falls on those studies that suggest principles at work in the artistic area and on studies that harbor lessons for educators in the arts. Developmental considerations reveal considerable flexibility in the options available to human societies in their educational and socializing practices. Studies of "individual differences" also document vast variations in the abilities, profiles, and potentials found across a population. Nonetheless, these options are not without limit: human beings evince certain strong inclinations and biases, even as they experience special difficulties in mastering certain forms of information at particular developmental points. These inclinations and obstacles are thrown into sharp relief when individuals are reared in schooled environments where they are expected to master certain specific bodies of knowledge within limited periods of time.

It is against such background information that policies in art education ought to be framed. Consistent with the values espoused in a culture, it should prove possible to devise curricula that are developmentally appropriate and that also address the significant differences found among individuals. It is also possible, though by no means easy, to develop methods of assessing which skills and which forms of knowledge students are mastering in their arts classes. The challenge in arts education is to modulate effectively among the values of the culture, the means available for arts education and assessment, and the particular developmental and individual profiles of the students who are to be educated.

ver since Charles Darwin established the centrality of evolutionary considerations in the study of life, scholars with an interest in human nature have addressed themselves to issues of human development. In the nineteenth century, the interest fell chiefly on comparisons across species, with human beings (and all too often, within that species, adult male Westerners) representing the apogee of human mental powers. Toward the end of the nineteenth century, this interest began to extend to development *within the life course* of the individual organism. And so, influenced by evolutionary concerns, investigators began to consider the steps or phases of development through which each normal individual passes in the course of mental, physical, social, and emotional growth. Sometimes, these considerations were actually based on case studies of the development of individual subjects; indeed, Darwin (1877) himself published diary notes on the infancy of one of his own children. For the most part, however, descriptions of development were based largely on "arm-chair" considerations of what it *must* be like to proceed from helpless infancy to the mastery of the adult. Even Freud (1905), who added immeasurably to our understanding of emotional development, defined his so-called "stages" retrospectively, on the basis of the testimony of adults being treated, rather than as a consequence of systematic observations of children over the course of development in one or another culture.

An epoch-making advance in this approach occurred in the early decades of this century. Building on the pioneering work of the early evolutionist James Mark Baldwin (1897), and on the first studies of human intelligence undertaken in the laboratory of Alfred Binet and Theodore Simon (1905), the Swiss biologist Jean Piaget for the first time carried out detailed and rigorous observational studies of the development of mental life in children. Indeed, Piaget (1970) actually established many of the observational and experimental methods for child development that continue to be used widely to this day. Piaget took seriously the Rousseauian proposition that children are not merely "stupid" or less well-informed adults. Rather, from early in life, human

beings exhibit their own particular forms of making sense of their surroundings, their own conceptions of the world.

In a portrait that is still considered generally accurate in its broadest scope, Piaget described infants as making sense of the world chiefly through their *sensori-motor* system, i.e., the use of their sense organs and their motor system; toddlers as beginning to master different *symbol systems* and grasping *intuitive* principles that govern the operation of the physical world; young school children as having a *concrete-operational* mastery of principles of logic, classification, and morality, i.e., they can reason when asked to work directly with physical objects or elements; and adolescents (at least in the West) as being able to reason in a *formal-operational* manner with symbols and propositions, in the manner of a scientist or a mature scholar. Moreover, Piaget made two extremely provocative claims: (1) These same stages obtain irrespective of the kind of material, or content, that the child is attempting to master; and (2) If a child is "at" a given stage with respect to one kind of content, the child will be "at" the same stage with respect to other contents.

Piaget did not deny differences among individuals or across cultures, but he was determinedly interested in documenting a universal pattern that extended to every normal human being on the planet. While he had some limited interest in educational issues, he was bent upon describing processes and forms of development that fall into place even in the absence of specific scholastic practices.

Just as Darwin and Freud established orthodoxies in the areas of evolution and psychodynamics, respectively, Piaget forged a view of cognitive development that became central—if not axiomatic—during the middle years of this century. Many investigators all around the world began using methods devised by Piaget to observe children. Thus, for example, they tested for "conservation of quantity" by asking children to judge whether liquid poured from a container of one shape into a container of different shape remained "the same amount"; or they tested for "decentering capacities" by asking children to judge how a diorama would look to someone sitting across the table from them. At least at first, investigators discerned broad parallels to Piaget's "stages" and "structures" of development in diverse cultures and in many fields of knowledge.

Moreover, and thanks principally to Piaget, investigators interested in human nature came to assume that the "developmental approach" was the proper one to assume with respect to children (cf. Werner, 1948). In sharp contrast to earlier behavioristic sentiments, scientists reached consensus that growth is more than simple change over time; that learning is more than mere association

or simple "impressions from the environment"; that human cognition cannot simply be extrapolated from studies of animal cognition; and that children themselves pass through a number of qualitatively different stages of understanding (Gardner, 1985). According to the new developmental dispensation, growth reflects a complex interaction between genetic predispositions and environmental opportunities, the results of which may be realized in somewhat different form in different settings but will in any event manifest certain core properties. Individuals do not develop merely by existing, or growing older, or becoming larger; they must undergo certain pivotal experiences that result in periodic reorganizations of their knowledge and their understanding. Indeed, measured in terms of milestones, an older child may be "less developed" than a younger one, and in later life there may well be regressions to earlier levels or forms of development. Finally, the developmental approach does not apply merely to children maturing in the world; a developmental framework can be applied as well to an individual's productions over time (including artistic ones), to the evolving state of knowledge in a field, and perhaps even to the relative sophistication of several populations (Kaplan, 1967).

The Piagetian-developmental synthesis lasted for perhaps two decades. Yet, as happens characteristically in the sciences, a new generation of researchers, deeply schooled in the Piagetian approach, began to discover weaknesses or omissions in the standard formulation (Brainerd, 1978; Bryant, 1974; Carey, 1985; Donaldson, 1978; Gelman and Gallistel, 1978). To begin with, researchers determined that many of Piaget's claims about stages were too heavily dependent on the specific methods of investigation that he had employed. When investigators used more familiar materials, or avoided the need for explanations on the verbal level, or stripped tasks down to their essence, they typically found that much younger children could solve the traditional Piagetian tasks. Thus, for example, children are better able to decenter when they are shown familiar displays (Borke, 1975); and they are better able to conserve quantities when they can pour the liquids themselves (Bruner, Olver, and Greenfield, 1966). Perhaps, they concluded, the younger children were as sophisticated developmentally, and the fault lay in experimental techniques.

Piaget's claims were called into question in another respect. When investigators probed in greater depth into the relationship between mastery of one kind of content and mastery of other contents, the neat fit that Piaget claimed to find did not hold. Youngsters, and especially youngsters with specific talents, might turn out to be extremely advanced developmentally with respect to one kind of material (say, logic), while they did not manifest correlative precocity with other

materials (for example, language or music or the understanding of other people) (Feldman, 1980, 1986; Gardner, 1983a).

More careful observations of individuals, especially those reared in different cultures, uncovered other deficiencies in the Piagetian perspective. Where Piaget portrayed children as more or less alike, students of individual differences within and across cultures documented enormous and enduring differences in cognitive styles and strengths of individuals. Such cognitive strengths and proclivities may well influence the ways in which individuals approach and master particular kinds of content. Individual differences of consequence for education were found to extend beyond the purely cognitive. Some stylistic proclivities (for example, impulsiveness) seemed to describe one group of children, while other proclivities (reflectiveness, imaginativeness, obsessiveness) described other groups. Parallel examinations of development in different cultures documented equally striking differences. Some cultures brought to the fore skills of mimicry or cooperative styles of learning, while other cultures encouraged exploratory behaviors or more competitive forms of mastery (Gardner, 1983a; Kagan and Kogan, 1970; Shweder and LeVine, 1984; Wagner and Stevenson, 1982).

Perhaps most striking were studies of the differences between "schooled" and "unschooled" cultures (Bruner, Olver and Greenfield, 1966; Luria, 1976; Scribner and Cole, 1973). Children who spend a significant number of years in school are better able than "unschooled" peers to handle issues and questions when these are encountered in an unfamiliar setting or when they have been divorced from their usual context; indeed, school can be seen as an institution that makes available to its clientele an ensemble of practices for dealing with such decontextualized materials—for example, the kinds of items routinely measured by standardized tests. (Put another way, school familiarizes the individual with a new kind of "stripped-down" context.) When individuals from unschooled environments are required to answer queries or solve tasks "in the abstract" or "without a familiar context," they find such tasks extremely difficult. Yet, paradoxically, when the "same" kinds of questions are posed in a familiar language or setting, these unschooled individuals perform at an unexpectedly high level (Cole, Gay, Glick, and Sharp, 1971). Whether unschooled individuals reason in a manner fundamentally different from those who have attended school, or whether the differences are superficial ones, remains a hotly debated issue within cross-cultural psychology (Horton and Finegan, 1973). By the same token, researchers have yet to agree on the extent to which different atmospheres in two classrooms—for example, the

contrasting Chinese and American classes described in the opening vignettes—exert meaningfully different influences on the ways in which students approach problems and fashion products.

A generation ago, there was reasonable consensus that human cognitive development occurs in the same Piaget-described way across cultures and individuals (Gardner, 1986). As a result of vigorous research in many settings during the past decades, a much more complex and less readily summarized perspective emerges. Imposed upon whatever broad stages of intellectual development may exist are significant differences across individuals, groups, and cultures. Periods of learning and forms of mastery turn out to be more flexible than had been thought.

And yet, there may well continue to be certain "floors" in what can be learned at a specific age as well as certain species "biases" in how materials are learned (Astington, Harris, and Olson, 1988; Carey, 1985; Fischer, 1980; Karmiloff-Smith, 1986; Keil, 1984; Rozin, 1976). For example, youngsters seem to categorize objects based on certain "prototypical examples" (rather than in terms of their conformity to a list of defining features); and they acquire facility in a skill well before they can describe in words what they are doing (meta-cognitive skills emerge late in development) (cf. Flavell, 1985). Researchers now recognize that the nature—and even the existence—of an educational system may also color the trajectories of human development within a culture.

Quite possibly reflecting a pervasive cultural bias in the West, nearly all major scholars in the area of human cognitive development have concurred on what it means to be a "well-developed" adult. Put simply, the developed individual is capable of the logical-rational thinking exhibited by mathematicians, scientists, and other scholars in our culture (Gardner, 1973, 1983a; Langer, 1969). Both the tasks chosen and the categories devised for the study of intellectual development exhibit this pervasive bias. The developing individual is seen as one who is gradually acquiring those habits of systematic classification, internally consistent explanation, rigorous principles of deduction, and timely application of organized rule systems that are the hallmark of Western science—at least as it has customarily been described in the opening chapters of elementary science textbooks.

So long as this portrait of development is widely shared, the study of human development seems reasonably straightforward. One defines the capacities of the mature adult as those of a rational problem-solving "computer" confronting a world of physical objects. Then, one "merely" devises tasks that tap those capacities, administers such measures to children of various ages (or differing degrees of sophistication), and then tallies where the younger child falls short. A subtler researcher may venture beyond the recording of deficiencies and, à la Piaget, try to document as well the particular "strategies" used by children in the course of their growth (Siegler, 1986). But, in any case, the focus of investigation falls upon problem-solving, not problem-finding; upon deficiencies, not strengths; upon the grasp of concepts, not skilled performance; and upon those tasks that can readily be described in terms of right and wrong answers, rather than those where the performance might equally well proceed in a number of directions.

A moment's reflection indicates that developmental psychology might have proceeded along quite a different path. Suppose, for example, that Piaget had started out as a musician, rather than

as a biologist; or that his followers had been trained in the visual arts, or in business, or in politics, rather than in the shadow of physics. Our notions of what it *means* to be developed, of the tasks that ought to be administered to children, of the ways in which these findings are interpreted could have evolved in a very different way (cf. Luquet, 1927; Sully, 1896). It would be as wrong to say that development ought to be studied exclusively from the perspective of the artist, as it is to contend that only the end-state of scientific competence is worth taking seriously. Clearly, a comprehensive science of human development needs in some fashion to consider the full spectrum of capacities and talents exhibited by mature human beings in diverse cultures.

During the past few decades, a broader-based approach to cognition—one that takes into account a range of human competences—has begun to take hold. This approach has its basis in philosophical studies, especially those undertaken by scholars interested in human symbol-using capacities. When human symbolic competences first began to be chronicled, it was customary to pay attention chiefly to those faculties that employed isolable and readily manipulable symbols. The ideal of symbolization was considered to be the realm of logic, where symbols could unambiguously designate numerical or linguistic elements and could be manipulated according to clearly specifiable rules. Language was also recognized as a central human symbolic form; whenever possible, language ought to be used with that precision and lack of ambiguity associated with scientific symbol systems. Poetry might have its place in human life, but it was best ignored when one sought an understanding of human cognitive competence, rationality, and thought (Ayer, 1936).

These ideas were directly challenged by a group of philosophers with a strong interest in the arts, specifically by the German philosopher Ernst Cassirer (1953–1957) and the American philosophers Susanne Langer (1942) and Nelson Goodman (1968, 1978). Each of these students of symbolization pointed out that the "logic-above-all" viewpoint was far too restrictive. As a species, human beings are capable of a vast number of symbolic competences, which extends well beyond logic and language in its scientific garb. Cassirer sought to capture the essence of myths, rituals, and other allusive forms of symbolization and to trace their connections to the apparently more rigorous forms of scientific thought. Langer pressed the difference between discursive forms of symbolization, where units could be identified unambiguously and manipulated according to specific rules; and presentational symbols, such as those featured in the arts, where the symbol did not allow itself to be divided up and had instead to be apprehended "as a whole."

More recently Goodman (1968) set up a set of syntactic and semantic criteria of *notationality.*

Only the most rigorous systems, such as those involved in mathematics and in Western musical notation, corresponded to the ideal of a fully notational system; other forms of symbolization, including those valued in the plastic and performing arts, deviate in specifiable and instructive ways from this ideal. These very departures allow for forms of communication—such as metaphoric expression—for which more rigidly structured symbolic codes are not suited.

Initially Goodman's inquiry began as a philosophical analysis, once descending linearly from the earlier efforts by Langer, Cassirer, and other semioticians. Like certain of his predecessors, however, Goodman became interested in the psychological implications of different kinds of symbolic competences. In fact, in his classic study *Languages of Art* (1968), Goodman speculated that different symbolic systems might well call for different kinds of symbol-using skills on the part of human beings; and he went so far as to suggest that these different skill profiles might prove to have educational consequences in the arts and in other disciplines as well. As he put it:

> *Once the arts and sciences are seen to involve working with—inventing, applying, reading, transforming, manipulating—symbol systems that agree and differ in certain specific ways, we can perhaps undertake pointed psychological investigation of how the pertinent skills inhibit or enhance one another; and the outcome might well call for changes in educational technology (Goodman, 1968, p. 265).*

These unpretentious sentiments became the charter in 1967 for Project Zero, an innovative, interdisciplinary, collaborative effort in arts education with which I and many other researchers have been involved over the past two decades.

While this essay is not the forum in which to provide an overall review of the progress of Project Zero (see, for example, Gardner, Howard, and Perkins, 1974; Gardner and Perkins, 1989; Perkins and Leondar, 1977; Winner, 1982), it is relevant to delineate the work of what eventually became known as the "Development Group" at Project Zero. Goodman had called attention to the range of human symbolic codes—language, gesture, picturing, musical notation, and the like—and to a spectrum of human symbol-using capacities, such as metaphoric expression, irony, self-reference, quotation, and the like. Given the suggestion that these symbolic capacities might have psychological consequences, it became natural (at least for developmental psychologists!) to ask about the development in children of various kinds of symbols competences.

Accordingly, since the late 1960s, the Developmental Group has sought to delineate the developmental course of various symbol-using capacities and skills, with a special emphasis on those capacities that are valued in the arts. To put it somewhat formulaically, researchers have

sought to cross Goodman's analysis of human symbolic functioning with the developmental approaches and methods devised by Piaget and his collaborators. Some of the work has been longitudinal: the same children have been observed at regular intervals over long periods of time as they gradually develop competence in different symbolic arenas (Gardner and Wolf, 1983). Much of the work has been experimental: adapting the approach of Piaget, researchers have designed measures of different aesthetic competences and assessed the way in which these competences unfold in the years of childhood (Gardner, 1980, 1982a; Winner, 1982). The research, when considered along with that of many other investigators, has yielded the beginnings of a portrait of artistic development as it occurs, at least among middle-class children in the contemporary American context.

As a background against which to review particular studies of artistic development, it is necessary to outline a view of artistic competence as it came to be held by the Project Zero group and by many other contemporary developmental investigators. Consistent with the analysis put forth by Goodman and his predecessors, artistry is seen primarily as an arena of human symbol use.

In adopting this conception there is no attempt to deny that the arts involve emotions, that they induce feelings of mystery or magic, or that they have a religious or spiritual dimension. Indeed, in this view, the emotions are seen to function cognitively—to guide the individual to make certain distinctions, to recognize affinities, to build up expectations and tensions that are then resolved. However, human artistry is viewed first and foremost as an activity of the mind, an activity that involves the use of and transformation of various kinds of symbols and systems of symbols. Individuals who wish to participate meaningfully in artistic perception must learn to decode, to "read," the various symbolic vehicles in their culture; individuals who wish to participate in artistic creation must learn how to manipulate, how to "write with" the various symbolic forms present in their culture; and, finally, individuals who wish to engage fully in the artistic realm must also gain mastery of certain central artistic concepts. Just as one cannot assume that individuals will—in the absence of support—learn to read and write in their natural languages, so, too, it seems reasonable to assume that individuals can benefit from assistance in learning to "read" and "write" in the various languages of the arts.

It might be asked whether there exist special rules pertaining to artistic symbol systems or to symbol systems used artistically. According to an analysis put forth by Goodman, no symbol system is inherently artistic or nonartistic (see Gardner, 1983b). Rather, symbol systems are mobilized to artistic ends when individuals exploit those systems in certain ways and for certain ends. To the

extent that a symbol system (like language) is used to communicate a single meaning in as unambiguous a manner as possible, with a strong possibility of accurate translation and summary, it is not functioning aesthetically. But to the extent that the same symbol system is used expressively, or metaphorically, or to convey a range of subtle meanings, or to evoke a certain emotional state, or to call attention to itself, it seems appropriate to say that the "same" symbol system is being used for aesthetic ends. The poet and the journalist may describe the same space launch, but their characteristic uses of language lead the poet to exploit aesthetic devices and ends that are of only limited relevance to the journalist's mission.

So described, the "symbolic developmental" approach may seem relatively simple and straightforward (though not thereby devoid of controversy). In practice, however, it is not apparent just how to apply these insights in the study of the development of artistry. That is because the research models and analyses developed with reference to mathematical and linguistic symbol systems cannot be automatically transported to aesthetic forms of symbolization and expression. Instead, in the case of each of the aesthetic forms and processes of interest, researchers have had to devise appropriate kinds of tasks, instruments, measures, and the like. In large measure, the history of research in this area chronicles a search for methods that can capture what is distinctive about artistic practice. One must be careful not to identify elements at too reduced a level—e.g., focusing on pure sounds rather than on musical patterns—which would make the results of questionable relevance to the arts. At the same time, once one has identified units that are representative of artistic practice, one must be able to come up with an analysis that allows systematic analysis, reduction and, where appropriate, quantification of the results.

Most developmentally oriented researchers, including those at Project Zero, have looked primarily at three aspects of children's competence in the visual arts: perception, conceptualization, and production. Probably the majority of studies have examined the development in children of the capacities to notice and to appreciate various aspects of paintings and other visual artistic forms. These studies document that children's sensory and perceptual powers develop very rapidly in early childhood. In terms of sheer perceptual acuity, the two-year-old sees the world very much like the sixty-year-old, and even the infant's perceptions are surprisingly like those of much more mature organisms (Bower, 1974; Gibson and Gibson, 1955; Hochberg, 1978). Of course, to see is not the same as to know what is important to notice (Perkins, 1975). As any connoisseur knows, it takes time and training to learn *how* to perceive in any domain: the knowledgeable sixty-year-old notices all kinds of materials and forms that are missed by the two-year-old or the twenty-year-old. In that sense, perceptual development in the visual arts may continue to unfold over a lifetime (Schapiro, 1953).

Any number of perceptual domains relevant to the arts could be subjected to empirical investigation. To give a feeling for the kind of research it is possible to carry out in the visual arts, let me describe a set of studies carried out nearly twenty years ago in the discrimination of artistic style. Without doubt, art connoisseurs must be able to examine works, including unfamiliar pieces, and be able to recognize stylistic aspects, including those that will enable them to make accurate attributions in the case of disputed works of art. So described, it might seem that only the mature adult can appreciate style (Parsons, 1989). On the other hand, there is much anecdotal evidence to suggest that even young children are able to make fine discriminations and to recognize individuals (or cars or animals) on the basis of incidental details (Lorenz, 1966). It thus becomes an intriguing empirical question to determine the ways in which young children are, and

are not, able to distinguish style in artistic works.

In a typical paradigm, school-aged children are exposed to a few works (the initial display) by a given "target" artist (whose identity is not disclosed) and then shown a few additional works (the "test" display). The task of the subject is to select from among the works in the test display, the single one that was created by the target artist. In order to succeed at this task, the subject has to ferret out from the initial display those features relevant to the recognition of the target artist's style, and then locate features in the test display that reveal which of the works have been fashioned by the target artist (Gardner, 1970; Gardner and Gardner, 1970; see also Frechtling and Davidson, 1970; Tighe, 1968; Walk, 1967).

An initial clutch of studies revealed that, when given this task "cold," young school children performed poorly (Coffey, 1968; Gardner, 1970; Machotka, 1966). That is, they tended to approach all works primarily in terms of subject matter. And so, when given the opportunity to group together works, they almost invariably put them together on the basis of common subject matter, in the process ignoring features of texture or composition that might be indicative of the artist's customary style. Only preadolescents displayed the capacity, on their own, of disregarding clues of subject matter and of paying attention instead to the way in which that subject matter was portrayed— the hallmark of sensitivity to style (DePorter and Kavanaugh, 1978).

Had researchers only carried out such studies, they would have drawn the conclusion that young school children are unable to appreciate artistic styles. As has typically happened in the case of post-Piagetian research, however, the actual trajectory of style development turns out to be far more complex.

First of all, the Project Zero research group determined that, in the absence of distracting subject matter cues, six-year-olds were as sensitive to style as were preadolescents. That is, when asked only to sort together abstract works in the same style, or when the subject matter itself was kept constant, sensitivity to style emerges as a powerful basis on which to classify. Investigators also discovered that, while the attraction to subject matter was initially a barrier, it was one that could be overcome. Spurning efforts to explain the concept of style didactically, experimenters instead simply rewarded youngsters whenever they sorted by style, even as they failed to reward subjects when they sorted by subject matter. This simple (even simple-minded) "behaviorist" approach resulted in a dramatic lowering of the age at which students are apparently able to attend to those stylistic features that are diagnostic of style (Gardner, 1972a, 1972b). Surprisingly, it

appeared that even six-year-olds are capable of attending to stylistic features. Some researchers have been able to demonstrate that even preschoolers are sufficiently sensitive to style that they can recognize the works of children in their class or their own works (Nolan and Kagan, 1980, 1981; Hartley and Somerville, 1982). Simple forms of instruction have also helped young subjects to attend to those features that are most diagnostic of an artist's style (Perkins, 1983). It would not amaze me if human toddlers—or for that matter even pigeons—could be trained to sort by style, should the contingencies of reward be properly arranged or the instructions be sufficiently articulated.

Further useful distinctions have emerged from other research laboratories. Hardiman and Zernich (1978, 1982) provided evidence that it may be attention to realism, rather than to subject matter per se, that undergirds the stylistic assessments made by children. Moreover, there may be a developmental aspect to this proclivity: possibly subject matter is the prevalent cue in early childhood, with criteria of realism coming to the fore by the years of middle childhood (Taunton, 1980).

Of course, it may legitimately be asked whether the capacity to sort together works on the basis of certain perceptual features demonstrates an understanding of the concept of style (Parsons, 1989). Surely the connoisseur engaged in attribution is doing more than disregarding subject matter and paying attention to occasional detail; she is trying to apprehend the vision of the artist and to recreate the individual and historical conditions under which the work was created (Gombrich, 1960; Schapiro, 1953; Wollheim, 1980). Moreover, "style sensitivity" in the minds of connoisseurs is a natural category of thought, which they bring to any artistic encounter, and not some kind of a strategy acquired to please a teacher or mollify an experimenter. The important point here is not a determination of whether eight-year-olds can or cannot appreciate style; clearly in some ways they can, and in some ways they still cannot. Rather, this line of research encourages one to sharpen one's definition of what is meant by (stylistic) competence; how best to "operationalize" this concept so that it can be measured in the research laboratory; and how then to interpret a large body of sometimes contradictory findings and to incorporate them into a broader view of artistic development (Gardner, 1972b, 1973).

This brief recapitulation of research on style sensitivity proves to be a useful example in the present context. In general, researchers working in the last two decades have found that even young children can display sensitivity to aesthetic aspects of works of art. Just like style, aspects of expression, composition, metaphor, texture, and balance can be apprehended even by relatively

untutored youngsters, provided that the alternatives are clearly laid out, some positive examples are modelled, and/or the subjects have the opportunity to familiarize themselves with the content and with the experimental paradigm (Gardner, 1974; Gardner and Winner, 1982; see also MacGregor, 1974; Seefeldt, 1979). (It is certainly easier for ten-year-olds to recognize styles of fashion or of popular music than to discriminate among old Dutch masters or among abstract expressionists of this century.) On the other hand, if left simply to their own devices, children do not show a "natural tendency" to focus on aesthetic aspects: salient traits of size, subject matter, realism, and color are much more likely initially to attract their attention (Hardiman and Zernich, 1978; Taunton, 1980). Finally, sophisticated forms of discrimination are only possible after many years of careful study: indeed, it has often been estimated that one can become a connoisseur only after a decade spent in careful study (Hayes, 1985), and the ten years seem to be necessary, rather than sufficient, for the attainment of connoisseurship in the arts.

These lines of research point to another very important aspect of developmental studies in the arts. In the investigations carried out initially by Piaget, a sharp distinction was drawn between concrete-operational thinking, where individuals reason on the basis of concrete examples, and formal-operational logical thought, where individuals reason on the basis of abstract propositional expressions, without respect to any particular content. Whatever the potency of this distinction in the sciences (and it has been much disputed there of late), it carries little force in the area of visual perception. When it comes to the perception of the visual world, the developmental curve seems to rise smoothly from early childhood, its limits being set not by age or by sheer exposure but rather by the extent to which relevant dimensions are identified and studied. In the absence of supporting cultural context, it is unlikely that anyone could become an artistic connoisseur. Under proper guidance, one could probably become a connoisseur at a young age. The great art historian Kenneth Clark was apparently able to remember with great fidelity any painting that he had ever seen; this fact makes it a bit easier to understand how he came to be appointed head of the National Gallery in London at the age of twenty-nine (Clark, 1976)!

A second line of study in the area of aesthetic sensitivity has centered on children's conceptualizations, hereafter, of the arts. At issue here is not what youngsters are able to perceive in any direct sense; but rather how they think about what they see, what sense they make of their and other's works, and, more broadly, how they reflect upon and understand the artistic enterprise. Whereas the use of language is at best incidental in the area of perception—and may in fact

obscure assessment of a child's discriminatory powers—language here proves of the essence. And indeed, children's conceptions are customarily studied by asking children about what they have seen and how they interpret it.

Early investigations revealed that, in the absence of tutelage, young children exhibit impoverished and often faulty conceptions of the arts (Gardner, Winner, and Kircher, 1975). They believe that works of art are produced by machines or have always existed; they feel that the merit of a work can be judged by its size, its subject matter, or (exclusively) in the costs of the materials; they fail to appreciate the reasons why someone might produce a work of art; and they seem unable to find any connection between their own artistic activities and the kinds of "high artworks" on display in museums or reproduced in books.

This research indicates that, by the age of ten or so, the most immature conceptions have been dissolved. And yet youngsters in middle childhood are still uncertain about the factors that enter into the production and the apprehension of works of art. Typically, at this age, they believe that there is a single standard by which works are to be judged; while they may not be cognizant of these standards, there must surely be "experts" who have these rankings all sorted out. Representational works—particularly those with photographic fidelity—are almost always esteemed, while those which deviate from illusionism, or which experiment with more formal features, are seen as deficient, if not decadent.

From an excessive faith in the legislatability of artistic canons, youngsters in adolescence often swing to an opposite point of view. Realizing that there are no inviolate standards of production or taste in the arts, they shift to the contrasting conclusion that *all* judgments in the arts are equally tentative; that no art work or artist merits any priority over any other; and that, in fact, there is no point in disputing over matters of taste. It is probably the case that these "relativistic views" endure in some form in many members of the adult population, and particularly in relation to modern artworks; when it comes to the contemporary art scene, most individuals find themselves incapable of rendering satisfactory evaluations and become skeptical that such valuations can ever be performed.

As with the earlier work on style perception, the accuracy and immutability of this developmental portrait has been challenged. For example, Rosario (1977) has raised the possibility that the answers provided by children may reflect the circumstances and wording of particular questions, rather than deeply held underlying conceptions. It is risky to attribute too much importance to

responses elicited with respect to issues that children may never have pondered before. Moreover, it remains to be determined whether, as in other developmental domains (Kohlberg, 1969), such conceptions are resistant to change, or whether they might quite readily be altered in the light of a modest training regimen.

A parallel line of research has sought to illuminate the different levels of understanding that individuals bring to works in the visual arts. In general, investigators here engage in open-ended interviews where they ask children to comment on which works they like and why, what they see in the works, how they make sense of their impressions, and which kinds of standards of taste and judgment should operate in the sphere of the visual arts (Brunner, 1975; Child, 1969; D'Onofrio and Nodine, 1981; Johnson, 1982; Machotka, 1966; Rosenstiel, Morison, Silverman, and Gardner, 1978; see especially Housen, 1983; Mockros, 1989; Parsons, 1987). The number of stages of comprehension that are identified, and the precise ways in which they are described, differ to some extent among investigators. Typically, however, the same general developmental progression has been described; the following portrait represents my synthesis of these various accounts.

Students at the primary school level prefer works on a purely idiosyncratic basis, often reflecting an event of significance in their recent past or some element on the canvas that reminds them of a favored person or object or color. A slightly more sophisticated approach mandates certain subject matter (e.g., landscapes) or style (e.g., realism) as inherently superior to others. Toward the latter years of childhood, subjects begin to report the emotional effects of works of art and speak in terms of expressive powers. An adolescent may well add to her discussions some consideration of formal properties, such as style, composition, or some mention of historical or cultural aspects, such as the milieu in which, or the reasons for which, the work was crafted. More sophisticated viewers are rare, except among those who have a professional or a deep avocational interest in the visual arts. Such individuals can draw on the full arsenal of "public" considerations (such as aesthetic or art-historical facets) with respect to a given work of art. In addition, they have developed their own aesthetic sensibility and set of standards, which continues to evolve gradually over time, and which they can apply, flexibly but with conviction and aptness, to new works or unfamiliar styles that they encounter; and they have constructed personal "autonomous" relations to specific works and styles, emerging as a dividend from the numerous interactions they have sustained with these works over the course of their lives.

By far the most elaborate developmental sequences of responses to works of art have been

worked out by Housen (1983) and Parsons (1987). Each of these investigators discerns a five-step developmental sequence in the responses given by American subjects in relatively open-ended discussions of representative works of art. There are clear differences in the two accounts: for example, Housen's stages are drawn from discussions with adolescents and adults, while Parsons has done much interviewing of children as well as older subjects; Parsons administered a relatively standard clinical interview to subjects, while Housen elicited "stream-of-consciousness" responses. Perhaps most important, there is an actual discrepancy in reported sequence of stages. Parsons's sequence proceeds from an affective orientation (stage 3) to a more formal approach (stage 4), while Housen's sequence has intellectual understanding (stage 3) preceding affective experience (stage 4) (Pariser, 1988). Still, what has struck most observers is the similarity in sequence observed by nearly all researchers, including the two that have carried out the most sustained work (Mockros, 1989). Such consensus is rare in the behavioral sciences and strongly suggests that we have here an instance of a genuine developmental sequence.

Unlike children's perceptual capacities, which can probably be induced to change with some speed, it is unlikely that older individuals' conceptions of art are susceptible to rapid transformation. To be sure, students can always be taught to say new things. But conceptualization seeks to probe beneath words, to get at the individual's overall understanding of the domain in question. While the issue has not been studied systematically in the arts, there is ample and quite persuasive evidence from other domains to suggest the following picture.

An individual's level of understanding of the arts emerges slowly as a result of his interactions in the artistic realm and his more general understandings of physical and social life (Kohlberg, 1969; Piaget, 1970; Turiel, 1969). Efforts to train an individual didactically to have a more sophisticated level of understanding are destined to fail. One can perhaps induce the parrotting of a response representative of a higher level; but such a response will prove fragile once the particular circumstances of the training have been removed. If one wants to enhance an individual's understanding, the most likely route is to involve her deeply over a significant period of time with the symbolic realm in question, to encourage her to interact regularly with individuals who are somewhat (rather than greatly) more sophisticated than she is, and to give her ample opportunity to reflect on her own emerging understanding of the domain. While (so stated) this sounds like a pedagogical recipe, it in fact more closely approximates the developmental course through which a connoisseur actually passes in the course of her training. Indeed, when it comes to the student's conceptualiza-

ANTIOCH UNIVERSITY
PROPERTY OF LIBRARY

tion and reconceptualization of the artistic realm, one encounters a domain that is apparently "developmental" in the sense originally described by Piaget.

The third, and most prominent form of study in artistic development, has focused on the development, in normal and sometimes in exceptional populations, of skills in visual artistic production. For the most part, the evidence here has come from those large collections of works that many parents—and especially those with educational, psychological, and/or aesthetic interests—have saved over the years. Dozens of these collections, containing millions of works, have been systematically surveyed in order to discover whether there are, in fact, "universal" stages of development of artistic production through which normal children pass in the course of childhood (For summary accounts, see Chapman, 1978; Gardner, 1980; Lark-Horovitz, Lewis and Luca, 1973; Kellogg, 1969; Lowenfeld, 1957; May, 1989; Read, 1943. For a view that questions the notion of a developmental sequence in production see Wilson and Wilson, 1981).

As is the case with artistic understanding, the broad contours of artistic production in the West have been amply verified in the past century. With little need for encouragement from adults, most two-year-olds enjoy scribbling. And they appear to discover on their own an ensemble of ways to make lines, dots, and simple geometrical forms. By the age of three or four, these youngsters are beginning to draw representationally: the human figure, certain animal figures, and some familiar objects like trees and suns punctuate the canvases of the preschooler. These renderings are not slavish copies of the objects, nor of drawings of the objects; rather, children at this time seek to create an equivalent in graphic form of their overall conception of the object (Arnheim, 1974). By the age of five or six, these objects are no longer strewn randomly across the paper; instead, the child has begun to organize the objects, generally with reference to the skyline or some other constricting feature like a floor or table top. By this age, it seems not unreasonable to conclude that the young child has a "first draft" understanding of how to make—and how to compose—a picture (see May, 1989).

Following the entry to school (and possibly related to it), children of seven or eight continue to draw, but they become increasingly interested in depicting acceptable content in acceptable form (Rosenblatt and Winner, 1988). Earlier, they took subject matter where they found it and were satisfied (if not eager) to experiment with unusual forms, color combinations, and compositional arrangements; now these school-age children become more conventional. Just as happens with their own taste, students appreciate most those works that closely resemble photographic realism;

and when they find that they cannot themselves achieve in their own drawings the desired degree of fidelity, they either revert to a hermetic kind of caricaturing or become discouraged altogether from drawing.

While this general picture is widely reported, there is considerable dispute about its significance and universality. Researchers are uncertain about whether the shift to a realistic aesthetic is a natural development, one brought about by the culture at large, or one spurred on by teachers, peers, or older students (May, 1989; see also Zurmuehlen, 1977). There is also attractive evidence that at least some youngsters harbor more than one aesthetic sensibility; while in school, they may follow the dictates of the classroom, they also carry on other forms of drawing—often of a more dramatic, expressionist, or ribald character—at home, in their journals, and even in public places ranging from subway cars to lavatories (Wilson and Wilson, 1977). Still, as a general rule, at least in the West, children begin to draw less frequently as they get older. Drawing skill is not much prized and other, more insistent, demands come to be made on their time. Those youngsters who continue to draw generally achieve a certain level of technical competence, though it may not approach that reached by even the average Chinese school child. However, at adolescence, a new synthesis may occur: the youth now weds his technical facility to a more personal vision, as artworks become an occasion for expressing—in a symbol system appropriate to the youth—needs, wishes, and anxieties of importance. When this kind of productive union can occur, the youth is likely to feel engaged and to continue artistic pursuits. But when (for whatever technical or personal reason) such a fusion cannot be realized, the youth is far less likely to remain involved in the arts, at least as a producer.

This picture of artistic development may be less true in other cultures than it is in the West. For one thing, in the absence of a period of relatively untrammeled exploration in early childhood, youngsters may begin to produce works of technical sophistication at a much earlier age (Gardner, 1989a). This facility means that the individual may feel more comfortable about continuing to draw; and indeed in traditional cultures, particularly before the invention of photography, it was not unusual for an adult to resort to drawing in order to retain or communicate a valued visual experience (Korzenik, 1985). However, it must also be said that in such societies the personal facets of drawing are downplayed, and so the possibility is lessened that artistic expression may become a treasured means of communication for the individual. Drawing remains, in short, a Craft rather than an Art Form.

Most studies of traditional societies yield portraits of early production similar to those put forth over the last century by Western investigators. It was therefore of special importance when the American anthropologist Alexander Alland had the opportunity to study the beginnings of drawing in a number of remote societies, including those where children had not drawn before. While he discovered some parallels, Alland was more impressed by the differences across populations and by the ways in which the values and atmosphere of those cultures were reflected in the first drawings:

> It is quite clear from the data that cultural influences appear early and have a strong effect on the overall style of children's drawing . . . generalizations about particular stages of development in children's drawing appear to be false . . . development from scribbling toward representation is not an automatic result of maturation, or even of experience with drawing. Children are often content to play with form and need not imbue this form of meaning . . . any universal aesthetic principles that may underlie successful art in different cultures will have to be generative rules rather than absolute determinants of form (1983, p. 214).

Clearly, the issue of "universals" in children's drawing has not been settled. An equally controversial issue centers on the question of the quality of children's artistic works. In centuries past, children's drawings were not attended to by adults, and the whole issue of the merit of these works would have scarcely arisen (Korzenik, 1981). In the past century, however, two events have occurred that have sharply increased adult interest in children's drawings. First of all, as part of the general interest in evolutionary issues, scholars have begun to look seriously at children's youthful production, and fledgling works of art emerge as among the most salient (and most appealing) of them. Second, Western artists themselves have begun to embrace styles and forms that are reminiscent of children's early artworks and artists as diverse as Pablo Picasso, Paul Klee, and Robert Motherwell have declared their strong interest in, and affinity to, the productions of young children. Given this confluence of factors, it is little wonder that a number of institutions are beginning to collect the artworks of children; far from being mere decorations on refrigerator doors, it is possible that selected children's works will soon begin to be displayed and traded for significant sums of money (cf. Ho, 1989).

But our interest here is pedagogical, not economic. In most spheres of development, it is simply assumed that individuals (and their products) get better with age. But in visual art production (and, for that matter, in other art forms as well), the developmental trajectory may be far more

jagged. That is, at least with respect to certain criteria, one might contend that the works of young children are as artistic, as imaginative, or as flavorful as those of considerably older individuals; and are perhaps more akin to the works of adult masters than are the works of somewhat older, but less adventurous, youngsters.

I have embraced the view that there are serious, nontrivial affinities between the young child and the adult artist (Gardner, 1973, 1980, 1982a; Gardner and Winner, 1982; Gardner, Wolf, and Phelps, in press). Members of both populations are willing to explore freely, to ignore existing boundaries and classifications, to work for hours, without the need for outside reward or stimulation, on a project that possesses them; perhaps more important still, for each of these groups, the arts provide a special, perhaps even unique, avenue of personal expression. Neither young children nor artists are necessarily comfortable expressing in discursive symbols their most important feelings and concepts; in fact they may not even feel able to engage in such expression. In *Artful Scribbles: The Significance of Children's Drawings* (1980), I illustrate some of the ways in which young children express their most dominant emotions and feelings through their drawings. For both of these groups, the arts may offer the best—and possibly the only—avenue for effective expression of what is important at the time. I am reminded of Isadora Duncan's famous quip, "If I could say it, I wouldn't have to dance it."

Even if there are important, though not yet widely realized, affinities between child and adult artists, we cannot conclude that children's art merits direct comparison with adult art. Here, my own view has become more modulated over the years. It is clear, for example, that children do not think of their artworks in the same way as do adults, and that they produce without reference to the artistic domain (what has been accomplished by other artists) and removed from the pressures of the artistic field (those culturally spawned judges who decide which art works have merit) (see Csikszentmihalyi, 1988). Only naive adults are similarly estranged from the artistic processes of their culture. It is also true that children's view of their works is, on the whole, more accepting and less critical than that of adults', that often they are interested chiefly in the processes of production and not in the final products, and that they cannot conceive of the development of a lifetime oeuvre or of solving problems over a long period of time.

For all that, however, it serves a useful purpose to compare children's work as objectively as possible with the work of older individuals, when that work has been gathered under comparable conditions (Davis, 1989). A number of studies suggest that, in dimensions like originality and

flavor, and sometimes even in aptness, young children perform significantly better (and significantly more like adolescents) than do youngsters in middle childhood (Gardner and Winner, 1982; Ives, Silverman, Kelly, and Gardner, 1981; Torrance, 1986; Winner, Blank, Massey, and Gardner, 1983). Parallel results have been reported in other art forms as well (Bamberger, 1978, 1982; Hargreaves, 1986; Pollio and Pollio, 1984; Torrance, 1986). It is worth noting again that this downturn in children's art occurs not long after children begin school, and that school may foster the change from flavorful toward flat. Children absorb the aesthetic values of their culture (Wilson and Wilson, 1979), and by and large adult society, including elementary teachers in this country and abroad, prefers realistic, representational works (Day, 1977; Gardner, 1989c; May, 1989; Rosario and Collazo, 1981; Zurmuehlen, 1977). Nevertheless, it seems important to consider the possibility that the arts may be especially characterized by "U-shaped curves of development"—by trajectories where the young individual and the mature individual share features in common that are not shared by an individual "in mid course" (Strauss, 1982).

Assertions regarding the affinities between child and adult art are controversial, among art connoisseurs as well as among social scientific researchers (Korzenik, 1981; Wohlwill, 1985). Certainly, what affinities exist pertain chiefly to the child-as-producer: there is no evidence that the critical, aesthetic, or historical powers of the young child are noteworthy. Yet, even for those loathe to accept parallels between child and adult artistry, this discussion can yield dividends. In making comparisons between what children and adults do, conceive, and understand, we are at least encouraged to sharpen our understanding of the nature of the artistic process, and our standards for what counts as art, and for what counts as good art. Moreover, we are reminded that decisions about art education cannot be made in a vacuum of values: what we think is meritorious in children's art, and how we relate juvenile productions of adult works, carry important implications for how we instruct the younger generation in a culture.

Until this point in the present essay, I have been concerned chiefly with those findings that emerge from naturalistic studies of children—children who live in Western culture, for the most part, and who attend school, but who have not received appreciable training that would equip them to handle our measures of artistic skills. Indeed, as much as possible, I have preferred to factor out the effects of school—to proceed in this investigation as if schooling did not exist and as if we could probe purely and directly into the mind of the child.

In following this research strategy, I have been faithful to the Piagetian tradition, which also is bent upon illuminating universal aspects of development. To my mind this has been a justifiable research strategy. It is defensible—and perhaps optimal—to begin by trying to unravel the aspects of development that occur simply by virtue of one's species membership. Building upon this knowledge, it then becomes appropriate to examine issues of individual differences and to probe the effects of school (Gardner, 1982b).

As David Feldman (1980, 1987) has pointed out, however, not all domains of importance can be considered universal. Increasingly, in the complex modern cultures of today, we are being asked to master materials and subject matters that were themselves invented by human beings, and sometimes in the not-too-distant past. The attainment of literacy, for example, is now, to all intents and purposes, a "cultural universal"; that is, while there may remain dozens of societies in which it is not considered important—or even possible—to become literate, in our culture literacy has become an imperative. In subcultures of diminishing size, it would be expected that individuals could learn to write, to master the calculus, or even to comprehend the theory of relativity. The "less universal" the domain, the more likely that an individual will require schooling (or at least some kind of formal training) in order to master it, and the more likely that significant numbers of

individuals will experience difficulty in attaining such mastery. No normal individual will fail to master the Piagetian conservations; a small percentage of normal individuals will be dyslexic and will experience undue difficulties in learning to read; but many individuals, perhaps even the majority, will never master the calculus, let alone the theory of relativity.

It was chiefly in order to allow young persons in a culture to master some of the "nonuniversal domains" that schools were initiated a few thousand years ago. Before that time, education took place largely at home or in the neighborhood of one's home, where youngsters observed adults at work and were soon drawn into the actual daily activities as helpers. At a certain historical point, it became clear that the prosperity—and perhaps even the survival—of the community was dependent upon the achievement of literacy by at least some members of the community; a new institutional form then became desirable. (Today, analogous trends may be taking place with reference to computer literacy.) By whatever means, different varieties of schooling came into being throughout the world.

By now, in our society, any attempt to tell the story of the development of mind becomes "contaminated" by the existence of schools and of individuals who have been to schools—such a contamination sometimes occurring as early as the age of two or three, and, more universally, by the age of six or seven. It is virtually impossible—even if it might for theoretical reasons be desirable—to factor out this scholastic element. And so the "developmental portraits" introduced above, which strive toward purity, are inevitably colored by their unfolding in a literate, schooled, and distinctly "nonuniversal" climate.

Even if schools are virtually inevitable, once literacy and other forms of knowledge have been deemed central by the community, it is by no means clear that schools are a comfortable locus of learning for the vast majority of individuals. Indeed, at the very least, schools call for a reorientation to the world that can be quite demanding for many individuals. Outside the setting of school, individuals learn skills and bodies of knowledge in rich, supportive, and essentially "natural" contexts, where information is highly redundant and feedback immediate and typically very relevant. In contrast, within most scholastic settings, the emphasis falls squarely upon learning information removed from the context in which it is likely to be used. Feedback is less regular and often is delivered in forms (like letter grades or corporal punishments) that do not actually facilitate subsequent learning—though for all that they may be effective motivators!

To ease the transition from "ecologically rich" forms of learning to the somewhat spare

scholastic setting, cultures have devised many institutional innovations, ranging from preschools to rites of passage to individual tutoring. This combination of methods may suffice to make school tolerable for a majority of individuals, though it has rarely, if ever, in human history produced a population that is genuinely fond of the scholastic environment and deeply committed to pursuing knowledge in the years following the completion of school. The fact that school is difficult for many, and enjoyable for relatively few, has not traditionally been a concern for most educators; after all, in earlier eras, schooling was restricted to a small elite, and the authority of masters went largely unchallenged. In the contemporary epoch, however, when the goal of universal schooling is being aggressively pursued, and teachers are being held accountable for the progress of their charges, the lack of appeal of school becomes a cause for concern. Those scholastic environments that succeed in making education palatable, or even enjoyable, are at a special premium.

For a considerable period of time, those researchers who study human development, and those who study learning in formal school settings, have proceeded in relative isolation from one another. As already suggested, developmentalists have been interested primarily in quasi-universal, virtually biological, constants. In contrast, educators have been much more attuned to the realities of classrooms, curricula, the training of teachers, the motivation of students, the standards of the community, and the assessment of outcomes by various kinds of formal and informal measures. To some extent, of course, this division of labor has been understandable and justifiable. If, however, one seeks to arrive at an educational regimen that makes sense from the perspective of our knowledge of the child's cognitive abilities and potentials, then a rapprochement between developmentalists and educators would appear to be critical.

In recent decades, developmentalists and educators have begun to listen to one another and even to try to speak the same language. By no means has this conversation been easy, but it has been instructive for both parties. Further dialogues will be necessary if progress is to be made in devising effective methods of education in fields ranging from physics to art education.

A synthesis of information drawn from developmental and educational studies suggests the existence of at least five different kinds of knowledge that any individual who grows up in a schooled environment must ultimately attempt to master and integrate (Gardner, in press a). During the very first years of life, as Piaget has shown, individuals acquire a considerable amount of knowledge simply by virtue of their interactions with physical objects and with other persons. Much of this knowledge is acquired through sensory perceptions and motor interactions, and it is

tapped chiefly through the stimulation of these capacities. Included here would be initial under-standings about the predictable behavior of objects in the environment, the motivations and intentions of other persons, the physical appearance of familiar entities, and other universally accessible forms of information. This form of knowledge is already well developed by toddler-age, and it continues to evolve, if at a reduced rate of change, throughout human life. Slightly adapting current usage, I will refer to this understanding as *intuitive knowledge*.

Beginning at the latest in the second year of life, a second form of knowledge becomes extremely important for all human beings (Olson and Campbell, 1989; Werner and Kaplan, 1963). At this point, individuals begin to use and to master the most widely available symbol systems of their culture—words, pictures, gestures, musical patterns, and the like. Again, assuming a normal constitution, this *first-order symbolic knowledge* is acquired readily, as part of one's species-specific membership. And for the most part, it is not difficult to map intuitive knowledge onto symbolic knowledge. The young child readily appreciates the relationship between the symbolic vehicles of words or pictures, for example—and the objects and events in the environment to which they refer—probably because these universally acquired symbol systems were originally fashioned precisely to capture these universal forms of intuitive knowledge.

While the first two forms of knowledge are assumed to exist in all cultures and with all normal individuals, the next two forms of knowledge are far more closely tied (and restricted) to scholastic settings. After the early years of childhood, at around the age of five to seven, children—and especially those who live in a schooled environment—begin to display signs that they wish to employ various kinds of notational systems (Olson, 1977; Vygotsky, 1978). These are the more formal symbolic codes—usually termed *notational systems*—that have evolved in literate cultures in order to refer especially to the first-order symbol systems. Hence, written language refers to oral language (as well as to its referents); written numerical systems denote oral and sensorily known quantitative information; written musical notational systems capture the defining features of the music valued in the culture; and various codes, graphs, maps, and the like capture other important symbolic and intuitive lessons. Mastery of these notational systems almost invariably requires at least some formal tuition, though the initial impulse for mastery may well evolve prior to formal schooling. Ultimately, many individuals will proceed to develop their own, more personal, forms of notation, but it is probable that such systems would not develop without the prior existence of "model" cultural notations.

The fourth form of knowledge, again closely tied to formal schooling, is the mastery of various concepts, principles, and *formal bodies of knowledge* that researchers, scholars, and reflective human beings have discovered, invented, and/or codified over the centuries. Initially, in preliterate cultures, these are the forms of knowledge available in percepts, myths, stories, and the like—the information that the culture passes on to its young. But in more developed or educated societies, there evolve formal bodies of knowledge—science, history, literary texts, and the like—with which the educated member of the culture is expected to be conversant (Hirsch, 1987). These go well beyond lists of information, to include, as well, frameworks for thinking productively in different disciplines and for attaining deeper understandings of those disciplines (Gardner, 1989d). Without formal schooling, there is little likelihood that average individuals in the society will be exposed to these materials and essentially no chance that they will master them. Indeed, the increasing length and demands of school reflect quite closely the greater amount of information that a growing individual is now expected to master.

Up to this point, our four forms of knowledge can be arrayed in a developmental scheme. On this account, intuitive knowledge is the first to emerge, and the one that evolves for the longest period of time. Symbolic knowledge emerges second and is in fact a precondition for notational knowledge, which presupposes it. The formal bodies of knowledge may begin to be known before the actual start of school, but their mastery and use takes many years and is certainly a relatively late form of knowledge. We may view these forms schematically as follows:

Figure i

The Emergence of Forms of Knowledge

Age:	Birth	Preschool	Formal School	Later Life
			Formal Disciplinary Knowledge	
			Notational	
		Symbolic		
	Intuitive			

A fifth form of knowledge must also be identified, even though it fits far less readily into our developmental scheme. I term this the development of *skilled knowledge*. Any culture harbors a collection of crafts, disciplines, and practices that must be mastered by at least some individuals, if the knowledge of the society is to be passed on to the next generation. This broad category includes a host of games, leisure activities, art forms, religious procedures, and vocations, each of which entails gradations of competence that extend from novice to master level.

In a traditional society, much of learning beyond intuitive and symbolic knowledge centers precisely around the acquisition of these skill clusters. For instance, in a traditional apprenticeship, the novice is drawn into the craft and lore of a valued adult occupation and gradually allowed to assume increasing responsibility and autonomy. He or she passes through a set of steps, or levels of competences, en route to the attainment of mastery. But even in the most complex technological societies, many disciplines are best thought of as bodies of skills to be acquired.

It should be evident why this form of knowledge cannot readily be inserted into our developmental scheme. On the one hand, aspects of skill acquisition date back to the earliest years of childhood, and, indeed, such valued skills as hunting, fishing, arts, or athletics clearly have their roots in the early sensori-motor or intuitive knowledge of the child. Yet, depending upon the sophistication of the craft and its surrounding society, mastery may include exposure to notational systems and/or bodies of codified knowledge. Here skills overlap with—and may presuppose—symbolic, notational, and/or formal knowledge. Certainly, an individual who wishes to become a surveyor or an electrician in a modern industrialized society would be expected to master all four developmentally arrayed forms of knowledge, in addition to whatever craft practices are mandated. Indeed, it could be said that the most skilled individual in a society has properly integrated these various forms of knowing within the envelope of a culturally valued discipline or craft (cf. Fischer, 1980).

The important point here is that, while craft or disciplinary knowledge is often highly sophisticated, learning of the constituent skills is not customarily seen as an acquisition of a scholastic sort; rather, it is treated as an area to be mastered by observation, direct involvement, and informal coaching, analogous to the manner in which initial intuitive or symbolic knowledge is ordinarily acquired. One might even go so far as to say that *each* form of knowledge can be thought of as permitting the emergence of a high level of skill—and indeed there are skilled symbol-users, notators, and formal disciplinarians. Yet, because many cultural practices—ranging from catching a

ball to driving a car to dancing the ballet—place so heavy an emphasis on physical skills, it seems preferable to view such forms of knowledge as a separate category, one with close affinities to nonscholastic forms of knowledge. Thus, skilled knowledge can be configured within our earlier scheme as follows:

Figure ii

The Place of Skills within the Forms of Knowledge

Age:	Non-Scholastic or Pre-Scholastic	Scholastic
		Formal Conceptual
		Notational
		Symbolic
	Intuitive	
	The origin of skills[1]	. .

[1]Integration of all available forms of knowledge.

Learning of both a formal (scholastic) and an informal (nonscholastic) sort has been taking place for several millenia, and those charged with education have reflected on these processes at least since classical times. Still, it must be said that we lack sufficient understanding of these forms of knowing. Indeed, most of the scientific research has focused particularly on the kind of sensori-motor knowing of which infants and animals are capable or on the kind of early notational knowledge that furnishes the agenda of the first years of school. Far less is known about the "natural" forms of symbolization in early childhood, the mastery of formal bodies of knowledge, and the acquisition of complex arts or craft skills in the course of apprenticeship.

Even more tellingly, educational and developmental researchers have only recently begun to appreciate the difficulty of *integrating* these various forms of knowledge into high levels of performance in disciplinary or craft areas. To be sure, as I've mentioned, the linking of intuitive and first-order symbolic knowledge seems to occur in normal individuals without undue difficulty. However, recent research documents that it is far more difficult to integrate other forms of knowing; indeed, all too often, these forms of knowing coexist in the same individual without appropri-

ate contact, let alone appropriate integration.

Let me cite a few examples of the numerous dissociations that have been documented. When young children are first encountering music, they amass considerable intuitive knowledge simply by listening to and singing music. For instance, they acquire a sense of how a work begins and ends, how various moods are expressed, how rhythm groups are organized and accentuated. These forms of knowledge, which are entirely serviceable for enjoying and making music, prove to be of a different order than that form acquired by the mastery of formal musical notation. The latter form of mastery seems essential if an individual is to become a full-fledged participant in the dominant musical traditions of the culture, for example, mastering the classical repertoire of understanding the nature of different interpretations of the "same" score.

In a series of studies, Jeanne Bamberger (1978; 1982) has convincingly demonstrated that the kinds of knowledge captured by formal musical notation are not consonant with those absorbed from sensory and practical exposures to music. For example, formal musical knowledge may dictate that one set of pitches belong together as a "group" (because they each have the same temporal value) while intuitive knowledge offers a different "group" (based on what makes a pleasing phrase). Formal knowledge may either mute the equally important intuitive knowledge or exist quite apart from it. In Bamberger's view, the task of musical education is somehow to preserve intuitive forms of knowing so that they can be properly integrated with more formal notational schemes as well as with the concepts and principles codified by musicologists.

Similar striking dissociations have been documented in the area of science, generally considered to be the prototypical formal body of knowledge. In this case, researchers have documented that intuitive sensori-motor or intuitive forms of knowing are quite robust. Students who have successfully completed college courses in physics, and have demonstrated their understanding *on a notational level* of many important Newtonian principles, end up reverting to the more primitive "Aristotelian concepts" once their formal instruction has ended. For instance, in a game context, students assume that, as a result of force striking an object at a certain angle, an object can simply be propelled in a certain direction; they fail to take into account the direction of its previous trajectory. Here is an instance where notational understanding exists quite apart from, and is not integrated with, the individual's earlier, more primary, forms of knowing (Caramazza, McCloskey, and Green, 1981; DiSessa, 1982; Posner, Strike, Hewson, and Gertzog, 1982).

One can further document the separate existence and functioning of these forms of knowledge.

In a sizeable number of studies, individuals incapable of solving formal arithmetical problems have been shown to exhibit in action the forms of understanding that they allegedly lack; for example, in shopping, carrying on a trade, or gambling at the race track, they can subtract or multiply the same combinations that elude them when these problems have been presented in written notational form (Ceci and Liker, 1988; Lave, 1988; Saxe and Gearhart, 1988; Scribner, 1986). Such findings are interpreted as evidence that a meaningful context may be necessary if certain forms of understanding are to be elicited. Accumulating evidence about "practical intelligence" indicates the lack of connection between IQ, as formally tested, and the ability of individuals to solve problems "on the street" or "at work" (Sternberg and Wagner, 1986). Finally, numerous studies of the attainment of expertise, in areas ranging from chess to computer programming to teaching, indicate that the most sophisticated individuals evolve heuristics (rough rules of thumb) that are quite effective, even though they may never have been formally taught (Berliner, 1989; Chi, Glaser, and Rees, 1982; DeGroot, 1965; Resnick, 1987).

Sound evolutionary principles may contribute to this surprising dissociation among various forms of knowing. While it might seem desirable that all forms of knowing be smoothly and automatically integrated, such an integration might interfere with rapid adaptation in circumstances of danger. Efficient performance often depends upon a holistic sizing up of which set of behaviors is needed in a given context: past habits may turn out to be a more reliable route to survival than the results of a formal computation geared to the specifics of the present situation. Also, formal bodies of knowledge change quite rapidly—far more so than the more basic forms of knowing —and it is often unclear which of the current "takes" on an area will in fact prove correct. It may remain more prudent to adopt those modes of action and reactions that have stood the test of time and are now incorporated in the genetic code.

What can be done to minimize the disjunction among forms of knowing, or, to put it another way, to heighten the integration among these various forms? There is an emerging consensus that the most promising methods involve "situated learning" (Brown, Collins, and Duguid, 1989; Resnick, 1987; see also Eisner, in press). When students encounter the various forms of knowing operating together in a natural situation; when they see accomplished adult masters moving back and forth spontaneously among these forms; when they are themselves engaged in rich and engaging projects, which call upon a variety of modes of representation; when they have the opportunity to interact and communicate with individuals who evidence complementary forms of

learning—these are the situations that facilitate a proper alignment among the various forms of knowledge. Often it is in the course of acquiring a complex, high-level skill that such combining occurs in a most ecologically reasonable manner. On the other hand, to the extent that each form is taught separately by individuals who themselves are not confident about the relationship between these modes, the chances that the forms of integrated knowing will emerge remain bleak indeed.

he five-fold scheme just presented is a new one, based upon studies of disciplinary knowledge carried out in formal and informal educational settings. Except for the research on music, and scattered instances in language (Olson, 1977), it has not been applied systematically in the arts. And yet, in my view, the ensemble of art forms can be readily and profitably analyzed in terms of these several forms of knowing.

In the case of the visual arts, young individuals participate in drawing activities, as creator and perceiver, from an early age, manifesting the intuitive and first-order symbolic forms of knowing. That is, they begin with sensori-motor activities by looking at and creating pictures, and they soon become able to "read" pictures in terms of their representational meanings and to create pictorial works that symbolize the referents and experiences of their world (Gardner, 1973).

Drawing serves as a paradigmatic example of an activity that can become a highly developed craft or skill. A not inconsiderable portion of drawing development can occur outside a scholastic setting, as students explore the drawing medium on their own and also examine the works done in their milieu (Wilson and Wilson, 1979). (The students in middle childhood often develop personal representational forms quite apart from schooling.) Further, by engaging in drawing as it is taught formally (e.g., in the classrooms of contemporary China), students can acquire a high level of skill in a venerable tradition. In the atelier, vast amounts of skill and craft knowledge have been handed down chiefly through apprenticeships and mentoring relations. Thus, the development of skill in drawing (and other visual art forms) can occur in both scholastic and nonscholastic settings.

The visual arts also include more formal ways of knowing. To begin with, works of art can be described in formal notational systems—for example, catalogues of color use, medium preference, or even sheer size; yet, as Nelson Goodman has pointed out (1968), the crucial (or "constitutive") aspects of the work per se may not be captured by such a code. Aestheticians, historians, art critics, and other students of the arts have over the years evolved a substantial corpus of formal knowledge

about artistic process, history, attributions, stylistic categorizations, and considerations of value. This form of knowledge will only be acquired through some kind of scholastic instruction, which until now has been restricted primarily to postsecondary education.

When one considers the ways in which artistic skills and knowledge have been transmitted in the past, the kind of dissociation that has characterized others forms of disciplinary knowledge might be less evident here. This is because, by and large, art education has occurred in the studio and so has consisted in the mastery of a craft, with its attendant informal lore. Though the historical record is anything but comprehensive on this score, we can assume that those cultures that value a high level of artistry have evolved elaborate forms of recruitment and training, but that these educational interventions have occurred almost entirely in a rich, supporting context. And so, while intuitive and craft forms of knowledge have been featured, there has been much less of a premium placed on formal notational use or on organized disciplinary knowledge. One might also think that, in the atelier, it would be possible to convey more scholastic forms of knowledge (such as historical or critical forms of knowing) in a more natural and realistic setting; but there is little direct evidence regarding the extent to which this was done in the past, and the practices were probably quite varied (cf. Vasari, 1976).

More formal art education began in schools in the West in the middle to latter parts of the nineteenth century (Freedman and Popkewitz, 1988; Wygant, 1983). By far the largest part of this education involved learning how to draw realistically, using two-dimensional models as well as models from life. In affluent circles, learning to render realistically was considered a sign of good breeding. In this respect, instruction in Western drawing had an affinity with the pursuit of excellence in artistry, archery, and musical performance that characterized the Chinese literati (Silbergeld, 1987). When drawing was introduced to ordinary citizenry in scholastic settings, the impetus was far more likely to be vocational in nature (Korzenik, 1985). Accurate drawing was seen as an important symptom of proficiency across a range of craft and skill areas.

Throughout this period, there was little training in the schools in artistic perception or reflection, and little attention was paid to organized bodies of knowledge in historical or critical studies (for some exceptions see Wygant, 1983). Such pursuits were left to the tiny minority who went on to attend colleges or universities, or to those wealthy enough to hire a tutor or guide who—as part of the fabled Grand Tour—would introduce students to the masterpieces on display in museums (and private collections) or to architectural landmarks. If there were exceptions—schools that

sought to integrate productive and discriminative skills—they were few and far between.

In the United States, the progressive education movement, in conjunction with European ideas about educational innovation for younger students, exerted significant impact on the art education available in public and private schools. Beginning in the early decades of the century, and continuing until recently, there has been a trend away from the mastery of representational depiction. (This trend was reinforced by the rise of photography as an art form and by the general trend toward abstract and other kinds of nonillusionistic art in the West.) The tendency has been to give students—and most especially those who are young—great latitude in how they approach the visual arts (Lowenfeld, 1957; for an interpretation, see Eisner, 1987). Art has been seen as continuous with other realms of experience, and the technical and craft components have been minimized (Dewey, 1934). Spurning the provision of models, most teachers of young children have preferred simply to provide materials and encouragement. As exemplified in our opening anecdote, art education has continued to be seen as a vehicle for promoting self-expression, imagination, creativity, and knowledge of one's affective life—not as a scholastic subject, not as a craft to be mastered.

Despite the pronounced shift in the last century with respect to the "mainstream" of production in American art education, there has, at least until recently, been little shift in the stance toward perceptual, historical, or critical studies (cf. Stake, 1989). In the nineteenth century, such education occurred almost entirely outside formal schooling; when works of art were displayed in school, they tended to be used to reinforce issues of patriotism, moral conduct, or broad philosophical themes. Observation and study of works of art was attempted, to some extent as part of the "picture study" movement at the turn of the century, but such practices became exceptional during the progressive era and the economic depression. Moreover, when works of art were examined, they were likely to be used to illustrate political ends, particularly those involving the struggles of labor or the plight of the poor and the dispossessed.

When, early in the 1980s, the Rockefeller Brothers Fund gave awards to exemplary programs in arts education, the award panel saw almost no examples of programs that emphasized full-scale study of works of art (Gardner, 1989a; Jones, 1989). Nearly all the programs featured a concentration on production, with the differences among programs inhering chiefly in the kinds of art produced, and the judged quality of those works. By the same token, when the Getty Trust (1985) undertook its survey of American arts educational practices a few years later, it found a similar

paucity of articulated programs that ventured "beyond creativity."

The question should be raised about why art education has taken these forms in the past century. An evident, but still essential, point is that, more than in any other country (China, for example), art education in the United States has been considered an unimportant part of a child's scholastic portfolio. Americans have always been ambivalent about the merits of the fine arts and especially so when it comes to allocating precious school minutes to a seemingly impractical or marginal pursuit (Harris, 1966). No wonder then that art education was most likely to flourish when the audience was independently wealthy, or when some vocational dividends were glimpsed.

Except among academics, interest in the noncraft aspects of artistry has always been limited. Few art teachers—and even fewer "general" teachers—know much about historical, critical, or aesthetic issues; and relatively few practicing artists are concerned with perceptual, conceptual, or reflective issues, except as they arise in the course of fashioning an artwork. It is hardly surprising that these potential areas of curriculum have been underdeveloped until now.

At various moments over the past quarter century, there have been serious efforts to place art education on firmer footing in American scholastic settings. Among the more notable efforts are those that grew out of the curriculum reform efforts of the early 1960s (Bruner, 1960, 1983; Ravitch, 1983). Even as scholars in other disciplines were searching for ways to convey to students the "core components" of their areas of knowledge, arts educators sought to build new and more rigorous curricula around the core components of artistic knowledge (Barkan, 1966a, 1966b; Clark, Day, and Greer, 1987; Smith, 1987). Assuming a more determinedly progressive cast, a panel of prominent Americans, chaired by David Rockefeller, Jr., argued strongly in favor of the wider dissemination of arts programs across the nation (Arts, Education, and the Americans, 1977; see also Fowler, 1988). There were also efforts to integrate arts education with other areas of school or of the community: for example, the study *The Museum as Educator* (Newsom and Silver, 1978) and various curricular efforts argued that artistic education exerted positive effects on other areas of learning, ranging from other art forms, to history and science, to the "basic skills" of reading, writing, or arithmetic. And there were continuing efforts to bring schoolchildren and artists closer together via various "Artists in the School" and "Young Audiences" programs.

It seems fair to say that, while each of these efforts appealed to a certain clientele and enjoyed a measure of success, none of them has significantly altered the status—or the nature—of art education in the broad swathe of American schools. As was true in earlier parts of the century, art

education is most prevalent (and in my view most vivid) in preschool and the early years of school; trained art specialists work mostly with older children, especially those who have an emerging vocational or strong avocational interest in the arts; production remains central, with some teachers more interested in the development of craft skills, others promoting self-expression or multicultural themes; and efforts to include within arts education aspects of perception, connoisseurship, and historical investigations have been infrequent and evanescent.

What may have emerged during the past two decades has been a consensual view among arts educators, most of whom now concur that an art education restricted to production is not sufficient (Broudy, 1972; National Endowment for the Arts, 1988). Reasons for this "change of mind" are varied and not necessarily consistent with one another. For instance, those who cite the need to pass on knowledge of the great masterpieces are not necessarily those who wish to improve perceptual discrimination powers or to avoid the indulgence of self-expressive ideologies. But the fact remains that educators are searching for the optimal way in which to provide to ordinary students aspects of artistic knowledge that, until now, have only been available to those who continue formal study of the arts, or to those who elect to take courses about the arts at the college or university level.

iven emerging consensus that art education should extend beyond the atelier and beyond "self-expression," the issue arises about which forms of education are possible and which are desirable, and how such forms might best be achieved. In what follows, I make no attempt to provide a direct recipe that could answer these questions; instead, I review the considerations that seem relevant if one is to reach an informed conclusion.

The difficulties that have arisen in efforts to educate individuals in other disciplines or domains are likely to recur—though in a characteristic form—in the arts. Just as it is not a straightforward matter to integrate intuitive, symbolic, notational, and formal knowledge with one another and with various "craft" skills, by the same token we cannot assume that students will be able to synthesize on their own the various forms of knowledge featured in the arts. To be concrete: One would need to integrate one's perceptual and motor knowledge of artistic production; the "reading" of the manifest representational content of works; various bodies of knowledge about art, including historical, critical, and philosophical investigations; and the kind of "hands-on" production skills that arise as a consequence of hundreds or thousands of hours at work with a medium. To revert to the developmental analysis in an earlier section of the paper: students would need to synthesize their own perceptual, conceptual, and productive knowledge.

Even if we were far more knowledgeable about artistic learning than we actually are, it is unlikely that we could arrive at a foolproof formula in arts education; values differ too greatly, across and even within, cultures. Individuals exhibit strikingly various forms of intelligences, skills, and understanding; each of the strands of artistic knowledge is likely to undergo its own characteristic developmental trajectory, and these are not necessarily consistent with one another. What is more reasonable is for educators to recognize the dimensions of the problem as I have outlined it; to approach the most important forms of understanding and learning from a number of complementary angles; to revisit important concepts and practices repeatedly during develop-

ment; and to maintain a flexible outlook on the kinds of understanding and skills that are likely to develop and on the uses to which these acquisitions of knowledge are likely to be put.

Reflecting my own value system, let me therefore put forth one possible scheme of art education. Assume that one wishes to secure a population of students who have some competence in artistic production in at least one medium; who have developed skills in looking at works of art, including those of masters, contemporaries, their peers, and their own work; who possess some understanding of the artistic process; and who are rooted in the historical, philosophical, and cultural traditions of art in their society. To be sure, this is a tall order: it goes well beyond what our and most other societies have sought for the bulk of their young; but it is certainly possible to aim this high and not impossible that one could achieve such an ambitious goal. How might one proceed?

In making informed choices about desirable programs directed toward this complex "end-state," findings from developmental, cognitive, and educational psychology can be of help. Before school age, any kind of formal artistic training appears to be unnecessary (Gardner, 1976). As we have noted, young children are superbly equipped to learn about the world of objects and persons, and they can make important—and even novel—discoveries without the need for adult intervention, except for the most general kinds of support and provision of materials. In order to create a rich visual environment, there is every reason to expose young children to significant artworks by adults. It is also productive to place children in contact with peers who possess artistic knowledge and skill as well as the ability to synthesize various forms of knowledge about the arts. On the other hand, there is little reason at this time to make these part of any explicit tutelage. Intuitive and first-order ways of knowing will operate without the need for anything except rich opportunities. Only in the case of those children who seem especially precocious in artistic production, or in those very few children who are unwilling or unable to undertake *any* visual artistic activity, would I recommend any kind of special intervention.

With the ushering in of the school years, children are quite capable of mastering notations and more formal bodies of knowledge about the arts. Here an important choice arises. Some authorities would embrace a fairly early and systematic introduction of bodies of knowledge about the arts —aspects of art history, a vocabulary for talking about the arts, some discussion of issues of judgment and value (Eisner, 1987; Robinson, 1987). The argument here is that children during the early school years are genuinely curious about their culture and how it operates. Conceptual and

formal knowledge about the arts is an important constituent of this cultural legacy, and one should begin early on to make children comfortable with these forms of knowing.

I agree that children in the elementary years are able to go beyond sheer production and to begin to enter into discussions of the nature and history of art objects. Yet, there are risks in embracing such an educational regimen, particularly if one fails to assume a developmental stance, or if the instructors are not deeply knowledgeable about the arts. While children can indeed begin to learn to "talk about art," there is a strong possibility that this talk will be acquired and evinced without integral relationship to the child's own art-making activity. Also, to the extent that "talk about art" comes to dominate the arts curriculum, one will have nipped in the bud the continuing developing of an important way of knowing—the visual-spatial knowledge that has begun to evolve in the young artist (Gardner, 1983a, 1983b).

I would therefore urge a measured introduction to conceptual and formal knowledge about art during the early school years. During this time, it is important to ensure that children who want to be able to continue drawing, painting, or modelling with clay have ample opportunity to do so, and to provide youngsters with the requisite technical skills and strategies so that they can progress as aspiring young artists. This is an age where youngsters are capable of mastering techniques and styles; of learning more difficult approaches, such as those of perspective; and of becoming involved in apprentice-type relations, where they can acquire various kinds of skill and lore in a more natural kind of setting (Gardner, 1980, 1982). I would not want to sacrifice this opportunity, which may never arise again. At the same time, it is worth noting that, for students with weak visual-spatial skills, talk about art may provide a welcome, powerful linkage to the artistic tradition.

To the extent that one elects to introduce the scholastic forms of knowledge about art, the manner of introduction becomes crucial. There is no need for this knowledge to be presented in isolation from the child's artistic productive powers. Rather, there is much to be gained from broadening the child's artistic knowledge through some form of "situated" learning.

One powerful technique during the years of early schooling is for students to become involved in projects of size and scope. Some of these projects can be grounded directly in the arts, when students build a set for a play, for example, or decorate their classroom for a celebration, or mount a series of works on a central theme or idea. Through involvement in these projects, students acquire not only artistic skills per se but also knowledge of what it means to carry out a significant undertaking, with appropriate support but not with undue help. These students also have the

opportunity to observe their own development and growth and their own personal contribution to a collaborative activity of some scope. And it may well be possible to evaluate these projects in ways that provide useful feedback for parents and for the students themselves.

In my view, it is in the course of working on their own projects that students ought gradually and sensitively to be introduced to notational and formal aspects of artistic analysis. When children are experimenting with different colors, they may well be primed to learn something of color theory; in producing variations on a theme, they may find other such variations undertaken by master artists to be interesting; in researching ancient Rome prior to a trip to Italy, an examination of architectural forms or kinds of fashions may become especially meaningful.

This regimen is particularly important to bear in mind with reference to the teachers of young children. Especially in those cases where the teacher has little arts training, there will be a tendency to try to teach art terms and concepts in a "decontextualized setting"—a list of dates, a set of definitions, a body of labels. If one wants these teachers to proceed beyond this disembodied formal knowledge, it is essential to create experiences and curricula for the teachers that embody an integral and rounded relationship between rich activities—like projects—and the formal-conceptual knowledge that one wants to convey. Of course, in the case of the teacher/artist who carries such integrated knowledge "in her bones," it is important for her to convey this integration by vivid example and appropriate modelling. Even a master artist can fall into the trap of saying "Well, children, let's put away our brushes now. Who can tell us when van Gogh was born?"

As one enters into the years of middle and high school, it becomes more feasible to present scholastic aspects of art "on their own." I would still urge prudence here. Those students who have observed how skills and conceptual knowledge can be integrated are far more likely to be able to do so when knowledge about art is encountered "out of context" than those who have never had the opportunity to fuse productive and conceptual aspects. Even through the later years of school, I favor a continuing primary engagement in projects, which will increasingly be designed by the students themselves to address their own interests and needs. (This procedure is now actually being used on a national scale in Great Britain, with initially impressive results. See Burgess and Adams, 1985.) The apprenticeship method is powerful and should only be abandoned for persuasive reasons. The major difference between art education for the seven-year-old and art education for the adolescent is this: older students should be prepared to undertake systematic study of the aforementioned scholastic aspects of art; and so I would favor the inclusion of options to take art

history or classes in artistic analysis. Still, in my view, these topics are less crucial for most students than the possibility of continuing active involvement in the arts as reflective practitioners (Schon, 1983). There will be time enough in university, and beyond, for these more "distanced" forms of artistic appreciation to become dominant.

My impassioned (and somewhat countercyclical) feelings about the need to keep artistic production central grows out of the earlier arguments about different forms of symbolization. Virtually definitional in the visual arts is the capacity to deal with visual-spatial kinds of symbols— to think in terms of forms, what they represent, what feelings they can express, how they can be composed and combined, and what multiple forms of significance they can embody. Some of these issues can be confronted via verbal and logical forms of symbolization—the forms normally favored in school. But many individuals with deep involvement in the arts believe that such "talk about art" is an ancillary form of knowledge, not to be taken as a substitute for "thinking" and "problem solving" in the medium itself (Arnheim, 1969; Eisner, 1972, 1978; Ewens, 1988; Read, 1943). It is because this form of knowing is so precious, and yet so threatened with being overwhelmed by the more typical scholastic modes of symbolization, that I call for the protection of artistic forms of symbolization. And, relatedly, because there are many students who possess this particular flair, while lacking equivalent linguistic and logical skills, we must make sure that one irreplaceable form of human symbolization remains vividly present in the schools. It would be a tragedy if a more conceptually based art education became yet another venue for verbally talented children to "show their stuff" while ceasing to provide a preserve for children with special visual, spatial, physical, or personal talents.

There is another reason for this insistence, which grows out of the special nature of the arts. In the arts, there are levels of development, as well as stages of expertise, and these should form a backdrop for any educational regimen. And yet, it is my belief that artistic forms of knowledge and expression are less sequential, more holistic and organic, than other forms of knowing (Dewey, 1934; Read, 1943), and that to attempt to fragment them and to break them into separate concepts or subdisciplines is especially risky. From the first artistic encounters, one gains a sense of the nature of the enterprise of creating and reflecting; this sense is never wholly lost but continues to evolve throughout one's life, so long as one remains actively involved in artistic activities. Consistent with the developmental perspective, growth involves a deepening of this knowledge, and an attainment of higher levels of understanding, rather than the simple accumulation of more facts,

more skills, or more bodies of knowledge—or, on the other hand, attainment of qualitatively different forms of knowing. We must be careful not to sacrifice this special nature of the arts—indeed, we might do well to allow this form of understanding to infiltrate other areas of the curriculum (Eisner, 1985; Gardner, 1973; Polanyi, 1958). The more that artistic activities and projects remain central, the more the apprenticeship model remains alive, the more likely it is that students will come to appreciate and assimilate the special nature of artistic learning and artistic knowledge.

ntil this point, my discussion of artistic development and education has been rooted in theoretical considerations, empirical research, and my own value system. Each of these make legitimate contributions to a discussion of arts education, but they stand naked in the absence of complementary efforts to determine the form they might take in a real school or in some other educational setting. During the last several years, my colleagues and I at Project Zero have become involved in a number of educational efforts in which the arts are an important component. As these efforts serve as a kind of "laboratory" for some of the notions about intelligence, development, and art education outlined above, I shall describe one of them briefly here. (For descriptions of other arts-related educational experiments, see Gardner, 1989b; Gardner and Feldman, 1989; Gardner and Hatch, 1989; Malkus, Feldman, and Gardner, 1988; Olson, 1988a.)

Arts PROPEL is a new effort in the area of arts assessment and curriculum. In many ways a child of its era, Arts PROPEL represents an attempt to go beyond "sheer production" in arts education and to expose students to formal and conceptual knowledge about the arts as well. Consistent with the developmental format, and with the recent cascade of findings about situated learning, Arts PROPEL's educational program seeks to create rich situations where students can easily and naturally oscillate among different forms of artistic knowing.

A collaboration with the Educational Testing Service and the Pittsburgh Public Schools, Arts PROPEL works with ordinary middle and high school children in the areas of music, imaginative writing, and visual art. Launched in the middle 1980s, Arts PROPEL had as its initial goal the development of new forms for assessing the growth of artistic intelligences. Yet, the collaborators soon discovered that, to assess an intelligence, it is vital that the student have the opportunity to work intensively with materials and to become familiar with their possibilities and limitations.

Hence, our work is now as fully in curriculum as in assessment (Gardner, 1989c; Olson, 1988b; Zessoules, Wolf, and Gardner, 1988).

In many ways, the key to Arts PROPEL is inherent in its name and in its chosen educational vehicles. The acronym stands for Production, Perception, and Reflection—the three components that we believe to be fundamental in all arts education. As much as possible, all of our educational efforts are designed to involve the fabrication an artistic work, the discrimination of important features in works of art, and the ability to stand back and reflect upon the meaning of artistic works—those created by others and those created by the students themselves.

It will be noted that the architects of Arts PROPEL do not make explicit reference to scholastic art pursuits, such as history, criticism, or aesthetics. This decision is deliberate, but should not be taken as a sign that we do not value these disciplines. Rather, as suggested above, we believe that historical, critical, and philosophical considerations ought to arise, for the most part, as a natural part of, or in response to, a student's own artistic productivity. And by using the terms "perception" and "reflection," we wish to underscore the point that artistic understanding need not occur merely through alliance with a different disciplinary content (such as the history or criticism of Western art); rather it ought to arise as part of one's own discriminative and reflective powers and ought then to be connected as smoothly and appropriately as possible to other bodies of knowledge.

This approach seeks to build on what we know about the different streams of learning. As I pointed out above, there is much evidence that, on their own, students do not connect material learned one way—say, as a craft skill—with that learned in a notational system or in a formal body of knowledge. There is every reason to expect that the same dissociations will occur in the arts. By explicitly fusing these activities together as much as possible, we hope to reconfigure artistic learning into a model of how forms of knowledge ought to be synthesized across the curriculum.

As our means of encouraging the melding of production, perception, and reflection, we have devised two "educational vehicles." *Domain projects* are rich and engrossing sets of curricular exercises designed to convey to students those concepts and practices deemed central to an art form and to allow these students to integrate their various forms of knowledge about the arts. These projects take place over several days and are so crafted that they can be injected into a variety of curricula. They have also been designed in such a way that students will have a stake in them. Thus, for instance, a domain project on "the biography of a work" might begin with

students making a painting of their own room at home, one which reveals something special about themselves. A domain project in the area of "style" might begin with the student's own handwriting and with attempts to produce, and understand, fakes and forgeries.

Complementing the array of domain projects that we are designing are student *portfolios* (which might more properly be called "process-folios," for they are designed to encourage exploring, revision, and other formative artistic processes). In daily life, portfolios are most frequently assembled by artists who are interested in gaining entrance to a school, competing for a prize, or securing a showing at a gallery. So constituted, they are collections of the best finished products. In contrast, our portfolios are deliberately designed to be records of "work(s)-in-progress." A typical, well-stocked student portfolio in the visual arts contains plans for works of art; initial drafts and sketches; early critiques of the work-in-progress; annotated "pivotal pieces," which appear to mark turning points in the development of the student's work (Brown, 1988); collections of associated materials, including related domain projects and works by other artists—both established and those known personally; a "final product," along with any observations and reflections by other individuals and by the student artist (Brown, 1988; Wolf, 1989); and perhaps a statement about or a sketch of a work to be undertaken in the future.

Both the domain projects and the portfolios reflect our belief that students learn best, and most integrally, from involvement in activities that take place over a significant period of time, that are anchored in meaningful production, and that build upon natural connections to perceptual, reflective, and scholastic artistic knowledge. These vehicles are also so designed that they can fit comfortably into a variety of classrooms and curricula, and so that students and teachers can make the best use of them for various purposes. Indeed, in Pittsburgh at present, most arts teachers modify "our" domain projects in ways that make them compatible with their particular curricular materials and goals.

Until now, I have not dwelled on the assessment component of Arts PROPEL, even though the project was originally devised as a means of assessing artistic growth and learning in ordinary school children. In part this omission has been deliberate: Arts PROPEL ought to be able to stand on its own, as a legitimate and worthwhile contribution to arts education. But the assessment dimension is also very important. Not only is it increasingly clear that the survival of arts programs depends upon our ability to document that students are actually learning something, but also the assessment ought to be a comfortable part of the student's own participation in artistic activity.

It may already be clear that my view of assessment differs markedly from that usually associated with scholastic settings (Gardner, in press, b; Gardner and Grunbaum, 1987). However useful they may be in traditional subject matter, I find little justification for the use of standardized, decontextualized instruments in the arts. Indeed, in many ways, such "instruments" seem directly antithetical to the arts. What makes far more sense, from my perspective, is for assessment to occur "in context" (Gardner, in press, b), as part of the student's ongoing artistic activities. In this way, one has the opportunity to observe how various forms of knowledge are developing and whether they can, in fact, work together effectively.

Thus, in our use of domain projects as well as portfolios, we identify points along the way at which students and teachers can reflect on what the goals are, what has been accomplished, where efforts have been misguided or inadequate, and which directions are most promising for future growth. As much as possible, we have tried to preserve that kind of natural reflection and conversation-on-the-fly that occurs in the course of any legitimate apprenticeship (and any bona fide mastery). In our own studies so far, both students and teachers find this form of assessment comfortable and appropriate; and both participants in the educational process feel that they benefit from incorporating assessment into the regular discussions that occur around the production of works and the execution of domain projects.

Of course, it is understandable that external bodies, such as school boards, may also want "hard data" about what is being accomplished in arts classes. For this reason, we have also been devising more "distanced" forms of assessment, where domain projects and portfolios can be assessed by knowledgeable individuals who do not, however, have any direct involvement with the students themselves. It seems fair to say that such assessment for the purpose of accountability is difficult, but not impossible, to accomplish. Holistic scoring methods, of the type developed at the Educational Testing Service for advanced placement competitions, work reasonably well with our artistic educational vehicles; developmental templates, which place works or projects within a set of levels of competence, also hold promise. For these forms of assessment, after all, it is not vital that one secure rigorously precise information on each student, especially at the risk of securing information that lacks validity in the technical sense. What is needed for accountability purposes is evidence that, in general, a cohort of students is advancing along dimensions of knowledge and practice considered important by knowledgeable experts in the field.

It is reasonable to ask whether Arts PROPEL is an instance of discipline-based arts educa-

tion. Inasmuch as there are no explicit guidelines for which programs qualify (or fail to qualify) for this label, the answer to this question calls for a subjective judgment. I prefer simply to view Arts PROPEL as a contemporary effort to create an arts education that encompasses the forms of knowing important in the arts and to do so in a way that fits current knowledge about human development and learning. In this sense, I think that I am in accord with my colleagues at the Getty Center for Education in the Arts.

n this essay I have described the various strands of knowledge that are relevant to a viable and effective art education. I began by reviewing scientific knowledge about human development in general, and then moved to a consideration of findings about human development from an artistic perspective. I sought to integrate this body of information with emerging insights about effective educational practices in different domains of knowledge. This review documented the challenge faced by students who seek to synthesize various forms of knowledge, ranging from sensori-motor and intuitive forms of understanding, to craft skills that can evolve to an exquisite level of mastery, to the notational and formal bodies of knowledge that are usually emphasized in the schools. I argued that, in the case of the arts, the development of these latter forms of knowledge should not occur at the expense of well-established educational regimens. In particular, it is important to honor those craft skills for which there is a long tradition of effective training, and which may feature—and foster—those ways of knowing that find their special genius—and their natural home—in the arts.

While my review of the literature does not lead directly to recipes for art education, it does suggest certain promising approaches. In the work undertaken with my colleages over the past several years, and in many studies of "situated learning," one encounters convincing evidence that students learn effectively when they are engaged by rich and meaningful projects; when their artistic learning is anchored in artistic production; when there is an easy commerce among the various forms of knowing, including intuitive, craft, symbolic, and notational forms; and when students have ample opportunity to reflect on their progress. Some of this reflection can be readily built into a system of informal classroom assessment, where it is most likely to be of use to the individual student. In addition, it appears possible to develop at least rough-and-ready assessment systems that can address issues of accountability for the wider community.

It is on the basis of our synthesis of knowledge about human development in the arts, and about the challenges of stimulating human learning, that we designed—and are continuing to redesign—an experimental approach to arts education. Beyond question, the approach in Arts PROPEL represents one of the multiple ways in which effective arts education can be developed. Far from wanting to question other efforts, framed in terms of differing theories, we welcome experiments in arts education from the most diverse quarters. There is little question that the whole field will learn from such efforts, much reason to think that superior art education is most likely to emerge as a result of accumulated knowledge about what works and what does not work under a variety of assumptions and in a variety of settings.

While researchers into human development and learning have acquired considerable knowledge in the past century, their studies have been conducted from a limited perspective. Thus we know far more about skills and knowledge of importance in the sciences than we do about comparable facets of the arts. And within the arts, far more is known about the natural development of artistic perception and production than has been established about the trajectory of historical, critical, or aesthetic forms of knowledge. It would be misleading to suggest that our findings dictate a certain educational approach. At most, they suggest that certain paths are more likely to be productive, while others are more likely to encounter pitfalls. Similarly, our limited experience in educational experimentation hardly suffices to suggest which attempts at intervention are more likely to "take hold."

Still, my recent experience in the realities of educational experimentation has convinced me that even the most brilliant curricular innovations will fail to be effective in the absence of two additional factors. First of all, it is imperative to have a cadre of teachers who themselves "embody" the knowledge that they are expected to teach. Unless teachers are in sympathy with, and feel some ownership of, the curricula materials, any educational efforts are doomed—be they discipline-based, Arts PROPEL, progressive, or conservative. Second, in the current educational climate, it is equally essential that there exist viable means of assessing what has been learned. Absent such measures, it is simply unrealistic to expect that communities will continue to support arts education, under whatever label it marches. Thus, if my study holds any implication for policy, it centers around the necessary trio of viable curricular materials, excellent teacher training, and suitable modes of assessment. This trio scarcely constitutes an original recipe, but it is one which bears repeating today.

At the same time that I encourage a wide range of educational experiments, I also want to stress how much can be learned by careful observation, documentation, and analysis of the practices that are already being implemented in settings around the world. In many ways, educational experimenters are at a disadvantage compared with other researchers because we cannot carry out the kinds of controlled studies that we may envision in our dreams; but we have the great advantage that the world as a whole has already mounted countless educational experiments, many of which can still be observed, recorded, and analyzed today. Different value systems, practices, and institutions abound and are there for our examination and study. Indeed, while some of the aspects of Chinese arts education are not particularly to my liking, I have learned a great deal as a result of my own observations in Chinese art classrooms; and some of the very procedures that I recommend, and that are being tried out in our own experiments, grow directly out of the lessons that I learned in Chinese classrooms (Gardner, 1989a, 1989b).

Observations in remote and even exotic settings, like China, remind one of something that must never be lost sight of in education: the importance of one's value system. The Chinese esteem high degrees of proficiency in their traditional art forms, even as they fear experiments in contemporary Western forms, and so their entire system is rooted in this nexus of desires and anxieties. American "progressives" are searching for ways to enhance expression, originality, and cultivation of individuality; hence, they stress certain materials and practices in their classrooms. Contemporary neoconservatives lament the loss of basic skills and core cultural values in the young of today, and so they call for educational practices that are anchored in the classical literacies and that elevate certain canonical texts. The kinds of education fashioned by these different interest groups will invariably reflect their values and their goals, and there is no way in which a "value-neutral" science can mediate among them. What scientific discovery and educational experimentation can furnish is some sense of how best to achieve one's stated goals, to demonstrate that success to others, to enumerate the costs involved in pursuit of a particular path, and, if one is fortunate, to minimize those costs. And it is just possible that a combination of the lessons learned from experiments at different points on the globe can suggest what set of values might be appropriate not only for a given society but for humanity as a whole.

Acknowledgments

Preparation of this essay was made possible by a grant from the J. Paul Getty Trust and its Center for Education in the Arts. I thank Leilani Lattin Duke and Stephen Mark Dobbs for their help in arranging this study and Phillip Charles Dunn for overseeing its completion. For comments on earlier drafts of this essay I thank Alberta Arthurs, Jessica Davis, Catherine Elgin, Elliot Eisner, Drew Gitomer, Nelson Goodman, Stephen Kaagan, David Olson, David Perkins, and Brent Wilson. Mindy Kornhaber aided me considerably in many phases of preparing this essay. The pilot projects in arts education described in the proposal were supported by grants from the Lilly Endowment, the Rockefeller Foundation, the Rockefeller Brothers Fund, and the Spencer Foundation, whose support is gratefully acknowledged.

Alland, A. 1983. *Playing with form*. New York: Columbia University Press.

Arnheim, R. 1969. *Visual thinking*. Berkeley: University of California Press.

Arnheim, R. 1974. *Art and visual perception: The new version*. Berkeley: University of California Press.

Arts, Education, and the Americans. 1977. *Coming to our senses: The significance of the arts for American education*. New York: McGraw Hill.

Astington, J., Harris, P.L., and Olson, D. R. (eds.). 1988. *Developing theories of mind*. New York: Cambridge University Press.

Ayer, A. J. 1936. *Language, truth, and logic*. New York: Dover.

Baldwin, J. M. 1987. *Mental development in the child and the race*. New York: Macmillan.

Bamberger, J. 1978. Intuitive and formal musical knowing. In S. Madeja (ed.), *The arts, cognition, and basic skills*. St. Louis: Cemrel.

Bamberger, J. 1982. Revisiting children's descriptions of simple rhythms. In S. Strauss (ed.), *U-shaped behavioral growth*. New York: Academic Press.

Barkan, M. 1966a. Prospects for change in the teaching of art. *Art Education* 19:5.

Barkan, M. 1966b. Curriculum problems in art education. In E. L. Mattil (ed.), *A seminar in art education for research and curriculum development*, 240–250. University Park: Pennsylvania State University.

Berliner, D. 1989. Implications of studies of expertise in pedagogy for teacher education and evaluation. In *New directions for teacher assessment: Proceedings of the 1988 ETS international conference*, 39–78. Princeton: Educational Testing Service.

Binet, A., and Simon, T. 1905. Methodes nouvelles pour le diagnostic du niveau intellectuel des anormaux. *L'année psychologique* 11: 235–336.

Borke, H. 1975. Piaget's mountains revisited: Changes in the egocentric landscape. *Developmental Psychology* 11: 240–243.

Bower, T. G. R. 1974. *Development in infancy*. San Franscisco: Freeman.

Brainerd, C. 1978. *Piaget's theory of intellectual development*. Englewood Cliffs, N.J.: Prentice-Hall.

Broudy, H. 1972. *Enlightened cherishing: An essay on aesthetic education*. Urbana: University of Illinois Press.

Brown, J. S., Collins, A., and Duguid, P. 1989. Situated cognition and the culture of learning. *Educational Researcher* 18(1): 32–42.

Brown, N. 1988. Pivotal pieces. *Portfolio* 1(2): 9–13.

Bruner, J. S. 1960. *The process of education*. Cambridge: Harvard University Press.

Bruner, J. S., Olver, R., and Greenfield, P. 1966. *Studies in cognitive growth: A collaboration at the Center for Cognitive Studies*. New York: Wiley.

Bruner, J. S. 1983. *In search of mind*. New York: Harper and Row.

Brunner, C. 1975. *Aesthetic judgment: Criteria used to evaluate representational art at different ages*. Unpublished doctoral dissertation. Columbia University.

Bryant, P. 1974. *Perception and understanding in young children*. New York: Basic Books.

Burgess, T., and Adams, E. 1985. *Records of achievement at sixteen*. Windsor, Berkshire: NFER-Nelson Publishing Co., Ltd.

Caramazza, A., McCloskey, M., and Green, B. 1981. Naive beliefs in "sophisticated" subjects: Misconceptions about trajectories of objects. *Cognition* 9(2): 117–123.

Carey, S. 1985. *Conceptual change in childhood*. Cambridge; MIT Press.

Cassirer, E. 1953–1957. *The philosophy of symbolic forms*. New Haven: Yale University Press.

Ceci, S., and Liker, J. 1988. Stalking the IQ-expertise relations: When the critics go fishing. *Journal of Experimental Psychology: General* 117(1): 96–100.

Chapman, L. 1978. *Approaches to art in education*. New York: Harcourt Brace Jovanovich, Inc.

Chi, M.T.H., Glaser, R., and Rees, E. 1982. Expertise in problem-solving. In R. Sternberg (ed.), *Advances in the psychology of human intelligence*, vol. 1. Hillsdale, N.J.: Lawrence Erlbaum Associates.

Child, I. 1969. Esthetics. In G. Lindzey and E. Aronson (eds.), *Handbook of social psychology*. Reading, Mass.: Addison-Wesley.

Clark, G., Day, M., and Greer, D. 1987. Discipline-based art education: Becoming students of art. *Journal of Aesthetic Education* 21: 129–186.

Clark. K. 1976. *Another part of the mind: A self-portrait*. New York: Ballantine.

Coffey, A. 1968. A developmental study of aesthetic preferences for realistic and nonobjective paintings. *Dissertation Abstracts International* 29 (1969): 4828B (University Microfilms No. 69–08869).

Cole, M., Gay, J., Glick, J. A., and Sharp, D. W. 1971. *The cultural context of learning and thinking*. New York: Basic Books.

Csikszentmihalyi, M. 1988. Society, culture, and person: A systems view of creativity. In R. Sternberg (ed.), *The nature of creativity*. New York: Cambridge University Press.

Darwin, C. 1877. A biographical sketch of an infant. *Mind* 2: 286–294.

Davis, J. H. 1988. *The artist in the child: A literature review of criteria for assessing aesthetic dimensions*. Qualifying Paper submitted to the Harvard Graduate School of Education.

Day, M. 1977. Effects of instruction on high school students' art preferences and art judgments. *Studies in Art Education* 18(1): 25–39.

DeGroot, A. 1965. *Thought and choice in chess*. The Hague: Mouton.

DePorter, D.A., and Kavanaugh, R.D. 1978. Parameters of children's sensitivity to painting styles. *Studies in Art Education* 20(1): 43–48.

Dewey, J. 1934. *Art as experience*. New York: Minton Balch.

DiSessa, A. 1982. Unlearning Aristotelian physics: A study of knowledge-based learning. *Cognitive Science* 6: 37–75.

Dobbs, S. (ed.). 1988. *Research readings for discipline-based art education: A journey beyond creating*. Reston, Va.: National Art Education Association.

Donaldson, M. 1978. *Children's minds*. London: Croom Helm.

D'Onofrio, A., and Nodine, C. F. 1981. Children's responses to paintings. *Studies in Art Education* 23(1): 14–23.

Duckworth, E. 1987. *The having of wonderful ideas and other essays*. New York: Teachers College Press.

Eisner, E. 1972. *Educating artistic vision*. New York: Macmillan.

Eisner, E. (1978). What do children learn when they paint? *Art Education* 31(3): 6–10.

Eisner, E. 1979. The forms and functions of educational connoisseurship and educational criticism. In E. Eisner (ed.), *The educational imagination*. New York: Macmillan.

Eisner, E. 1985. Educational imagination: On the design and evaluation of school programs (2nd ed.). New York: Macmillan.

Eisner, E 1987. *The role of discipline-based art education in America's schools*. Los Angeles: The Getty Center for Education in the Arts.

Eisner, E., in press. Implications of artistic intelligences for education. In W. Moody (ed.), *Artistic intelligences: implications for education in a democracy*. New York: Teachers College Press.

Ewens, T. 1988. Flawed understandings: On Getty, Eisner and DBAE. In J. Burton, A. Lederman, and P. London (eds.), *Beyond DBAE: The case for multiple visions of art education*. University Council on Art Education.

Feldman, D. H. 1980. *Beyond universals in cognitive development*. Norwood, N.J.: Ablex.

Feldman, D. H. 1986. *Nature's gambit*. New York: Basic Books.

Feldman, D. H. 1987. Developmental psychology and art education: Two fields at the crossroads. *Journal of Aesthetic Education* 21: 243–259.

Fischer, K. 1980. A theory of cognitive development: The control of hierarchies of skill. *Psychological Review* 87(6): 477–531.

Flavell, J. 1985. *Cognitive development*. Englewood Cliffs, N.J.: Prentice-Hall.

Fowler, C. 1988. *Can we resecure the arts for America's children: Coming to our senses—10 years later*. New York: American Council for the Arts.

Frechtling, J. A., and Davidson, P.W. 1970. The development of the concept of artistic style. *Psychonomic Science* 18(2): 79–81.

Freedman, K., and Popkewitz, T.S. 1988. Art education and social interests in the development of American schooling: Ideological origins of curriculum theory. *Journal of Curriculum Studies* 20(5): 387–405.

Freud, S. (1905). Three contributions to the theory of sex. In A. A. Brill (ed.), *The basic writings of Sigmund Freud*. New York: Random House, 1938.

Gardner, H. 1970. Children's sensitivity to painting styles. *Child Development* 41: 813–821.

Gardner, H. 1972a. The development of sensitivity to figural and stylistic aspects of paintings. *British Journal of Psychology* 63: 605–615.

Gardner, H. (1972b). Style sensitivity in children. *Human Development* 15: 325–338.

Gardner, H. 1973. *The arts and human development*. New York: Wiley.

Gardner, H. 1974. Metaphors and modalities: How children project polar adjectives onto diverse domains. *Child Development* 45: 84–91.

Gardner, H. 1976. Unfolding or teaching: On the optimal training of artistic skills. In E. Eisner (ed.), *The arts, human development, and education*. Berkeley, Calif.: McCutchan Publishing Company.

Gardner, H. 1979. Entering the world of the arts: The child as artist. *Journal of Communication* (Autumn): 146–156.

Gardner, H. 1980. *Artful scribbles: The significance of children's drawings*. New York: Basic Books.

Gardner, H. 1982. *Developmental psychology: An introduction*. Boston: Little, Brown.

Gardner, H. 1982a. *Art, mind, and brain: A cognitive approach to creativity*. New York: Basic Books.

Gardner, H. 1982b. Response to comment on Project Zero by Jessie Lovano-Kerr and Jean Rush. *Review of Research in Visual Arts Education* 15: 82–84.

Gardner, H. 1983a. *Frames of mind: The theory of multiple intelligences*. New York: Basic Books.

Gardner, H. 1983b. Artistic intelligences. *Art Education* 36: 47–49.

Gardner, H. 1985. *The mind's new science*. New York: Basic Books.

Gardner, H. 1986. Notes on cognitive development: Recent trends, future prospects. In S. Friedman, K. Klivington, and R. Peterson (eds.), *The brain, cognition, and education*. New York: Academic Press.

Gardner, H. 1989a. *To open minds: Chinese clues to the dilemma of American education*. New York: Basic Books.

Gardner, H. 1989b. The key in the key slot. *Journal of Aesthetic Education* 23(1): 141–158.

Gardner, H. 1989c. Zero-based arts education: An introduction to Arts PROPEL. *Studies in Art Education* 30(2): 71–83.

Gardner, H. 1989d. The academic community must not shun the debate on how to set national educational goals. *Chronicle of Higher Education* (November 8, 1989): A 52.

Gardner, H., in press, a. The difficulties of school: Probable causes, possible cures. *Daedalus*.

Gardner, H., in press, b. Assessment in context: The alternative to standardized testing. In B. Gifford (ed.), *Report of the Commission on Testing and Public Policy*. Boston: Kluveo.

Gardner, H., Feldman, D., et al. 1989. Final report on Project Spectrum. Submitted to the Spencer Foundation.

Gardner, H., and Gardner, J. 1970. Developmental trends in sensitivity to painting style and subject matter. *Studies in Art Education* 12: 11–16.

Gardner, H., and Grunbaum, J. 1987. The assessment of artistic thinking: Comments on the National Assessment of Educational Progress in the Arts. Commission on National Assessment of Educational Progress.

Gardner, H., and Hatch, T. 1989. Multiple intelligences go to school. *Educational Researcher* 18: 4–10.

Gardner, H., Howard, V., and Perkins, D. 1974. Symbol systems: A philosophical, psychological, and educational investigation. In D. Olson (ed.), *Media and symbols: The forms of expression, communication, and education*. Chicago: University of Chicago Press.

Gardner, H., and Perkins, D. (eds.). 1989. *Art, mind, and education*. Urbana: University of Illinois Press.

Gardner, H., and Winner, E. 1982. First intimations of artistry. In S. Strauss (ed.), *U-shaped behavioral growth*. New York: Academic Press.

Gardner, H., Winner, E., and Kircher, M. 1975. Children's conceptions of the arts. *Journal of Aesthetic Education* 9: 60–77.

Gardner, H., and Wolf, D. 1983. Waves and streams of symbolization. In D. R. Rogers and J. A. Sloboda (eds.), *The acquisition of symbol skills*. London: Plenum Press.

Gardner, H., Wolf, D., and Phelps, E., in press. The roots of creativity in children's symbolic products. In C. Alexander and E. Langer (eds.), *Beyond formal operations*. New York: Oxford University Press.

Gelman, R., and Gallistel, C.R. 1978. *The child's understanding of number*. Cambridge: Harvard University Press.

The Getty Center for Education in the Arts. 1985. *Beyond creating: The place for art in American schools*. Los Angeles: The Getty Center for Education in the Arts.

Gibson, J. J., and Gibson, E. J. 1955. Perceptual learning: differentiation or enrichment? *Psychological Review* 62: 32–41.

Gombrich, E.H. 1960. *Art and illusion*. Princeton: Princeton University Press.

Goodman, N. 1968. *Languages of art*. Indianapolis: Bobbs-Merrill

Goodman, N. 1978. *Ways of worldmaking*. Indianapolis: Hackett.

Gulbenkian Foundation 1982. *The arts in school*. London: Calouste Gulbenkian Foundation.

Hardiman, G.W., and Zernich, T. 1978. Influence of style and subject matter on the development of children's art preferences. *Studies in Art Education* 19(1): 29–35.

Hardiman, G.W., and Zernich, T. 1985. Discrimination of style in painting: A developmental study. *Studies in Art Education* 26(3): 157–162.

Hargreaves, D. J. 1986. *The developmental psychology of music*. New York: Cambridge University Press.

Harris, N. 1966. *The artist in American society: The formative years*. New York: Braziller.

Hartley, J. L., and Somerville, S. 1982. Abstraction of individual styles from the drawings of five-year-old children. *Child Development* 53: 1193–1214.

Hayes, J. R. 1985. Three problems in teaching general skills. In J. Segal, S. Chipman, and R. Glaser (eds.), *Thinking and learning skills*, vol. 2. Hillsdale, N. J.: Lawrence Erlbaum Associates.

Hirsch, E. D. 1987. *Cultural literacy*. Boston: Houghton Mifflin.

Ho, Wai-ching, (ed.). 1989. *Yani: The brush of innocence*. New York: Hudson Hills Press.

Hochberg, J. 1978. *Perception*. Englewood Cliffs, N. J.: Prentice-Hall.

Housen, A. 1983. *The eye of the beholder: Measuring aesthetic development*. Unpublished doctoral dissertation. Harvard Graduate School of Education.

Horton, R., and Finegan, R. (eds.) 1973. *Modes of thought: Essays on thinking in Western and non-Western societies*. London: Faber and Faber.

Ives, S. W., Silverman, J., Kelly, H., and Gardner, H. 1981. Artistic development in the early school years: A cross-media study of story-telling, drawing, and clay modelling. *Journal of Research and Development in Education* 14: 91–105.

Johnson, N.R. 1982. Children's meanings about art. *Studies in Art Education* 23(3): 61–67.

Jones, L. B. (ed.). 1989. A report on the Rockefeller Brothers Fund awards in Arts Education Program (July draft). New York: Rockefeller Brothers Fund.

Kagan, J., and Kogan, N. 1970. Individual variation in cognitive process. In P. Mussen (ed.), *Manual of child psychology*. New York: Wiley.

Kaplan, B. 1967. Meditations on genesis. *Human Development* 10, 65-87.

Karmiloff-Smith, A. 1986. From meta-processes to conscious access: Evidence from children's metalinguistic and repair data. *Cognition* 23: 95–147.

Keil, F. 1984. Mechanisms in cognitive development and the structure of knowledge. In R. Sternberg (ed.), *Mechanisms of cognitive development*. San Francisco: Freeman.

Kellogg, R. 1969. *Analyzing children's art*. Palo Alto, Calif.: National Press Books.

Kohlberg, L. 1969. Stage and sequence: The cognitive-developmental approach to socialization. In D. A. Goslin (ed.), *Handbook of socialization theory and research*. New York: Rand McNally.

Korzenik, D. 1981. Is children's work art? Some historical views. *Art Education* 34(5): 20–24.

Korzenik, D. 1985. *Drawn to art: A nineteenth-century American dream*. Hanover, N. H.: University Press of New England.

Langer, J. 1969. *Theories of development*. New York: Holt, Rinehart, and Winston.

Langer, S. 1942. *Philosophy in a new key*. Cambridge: Harvard University Press.

Lark-Horovitz, B. L., Lewis, H., and Luca, M. 1973. *Understanding children's art for better teaching*. Columbus, Oh.: C. E. Merrill.

Lave, J. 1988. *Cognition in practice: Mind, mathematics and culture in everyday life*. Cambridge and New York: Cambridge University Press.

Lorenz, K. 1966. The role of Gestalt perception in animal and human behavior. In L. L. Whyte (ed.), *Aspects of form*. Bloomington, Ind.: Midland Books.

Lowenfeld, V. 1957. *Creative and mental growth*. New York: Macmillan.

Luquet, G. 1927. *Le dessin enfantin*. Paris: Alcan.

Luria, A. R. 1976. *Cognitive development*. Cambridge: Harvard University Press.

MacGregor. R. 1974. Response strategies adopted by elementary school children to items in a perceptual index: An exploratory study. *Studies in Art Education* 16(3): 54–61.

Machotka, P. 1966. Aesthetic criteria in childhood. *Child Development* 37: 877–885.

Malkus, U., Feldman, D., and Gardner, H. 1988. Dimensions of mind in early childhood. In A. Pelligrini (ed.), *The psychological bases of early education*, 25–38. Chichester: Wiley.

May, W. 1989. Understanding and critical thinking in elementary art and music. Center for the Learning and Teaching of Elementary Subjects. East Lansing: Michigan State University.

Mockros, C. 1989. *Aesthetic judgment: An empirical comparison of two stage developmental theories*. Master's thesis. Submitted to Tufts University Eliot-Pearson Child Study Center.

National Endowment for the Arts. 1988. *Towards civilization: A report on arts education*. Washington, D.C.: The National Endowment for the Arts.

Newsom, B., and Silver, A. 1978. *The museum as educator*. Cleveland: Cleveland Museum of Art.

Nolan, E., and Kagan, J. 1980. Recognition of self and self's products in preschool children. *Journal of Genetic Psychology* 137: 285–294.

Nolan, E., and Kagan, J. 1981. Memory for products in preschool children. *Journal of Genetic Psychology* 138: 15–26.

Olson, D. (Ed.) 1974. *Media and symbols: The forms of expression, communication and education*. Chicago: University of Chicago Press.

Olson, D. 1977. From utterance to text: The bias of language in speech and writing. *Harvard Education Review* 47: 257–282

Olson, D., and Campbell, R. 1989. Representations and misrepresentations: On the beginnings of symbolization in young children. Manuscript in preparation.

Olson, L. 1988a. Children flourish here: Eight teachers and a theory changed a school world. *Education Week* 7(18): 1, 18–20.

Olson, L. 1988b. In Pittsburgh: New approaches to testing track arts 'footprints.' *Education Week* 8(11); 1, 22–23.

Ott, R. W., and Hurwitz, A. 1984. *Arts in education: An international perspective.* University Park: Pennsylvania State University.

Pariser, D. 1988. Review of Michael Parsons's *How we understand art. Journal of Aesthetic Education* 22(4): 93–102.

Parsons, M. 1989. Understanding style. *New Ideas in Psychology.*

Parsons, M. 1987. *How we understand art.* New York: Cambridge University Press.

Perkins, D. 1975. Noticing: An aspect of skill. Paper given at the NIK conference on basic mathematical skills and learning. Volume I: Contributed Position Papers.

Perkins, D., and Leondar, B. (eds.). 1977. *The arts and cognition.* Baltimore: Johns Hopkins University Press.

Perkins, D.N. (1983). Invisible art. *Art Education* 36(2): 39–41.

Piaget, J. 1970. Piaget's theory. In P. Mussen (ed.), *Manual of child psychology.* Vol. I, 703-730. New York: Wiley.

Polanyi, M. 1958. *Personal knowledge.* Chicago: University of Chicago Press.

Pollio, M., and Pollio, H. 1974. The development of figurative language in school children. *Journal of Psycholinguistic Research* 3: 185–201.

Posner, G.J., Strike, K.A., Hewson, P.W., and Gertzog, W.A. 1982. Accommodation of a scientific conception: Toward a theory of conceptual change. *Science Education* 66(2): 211–217

Ravitch, D. 1983. *The troubled crusade.* New York: Basic Books.

Read, H. 1943. *Education through art.* New York: Pantheon (reprinted without date).

Resnick, L. 1987. Learning in school and out. *Educational Researcher* 16(10): 13–20.

Robinson, K. 1987. The arts in the national curriculum. *The Arts in Schools Project Newsletter.* No. 7 (December 1987).

Rosario, J. 1977. Children's conceptions of the arts: A critical response to Howard Gardner. *Journal of Aesthetic Education* 11(1): 91–100.

Rosario, J., and Collazo, E. 1981. Aesthetic codes in context: An exploration in two preschool classrooms. *Journal of Aesthetic Education* 15(1): 71–82.

Rosenblatt, E., and Winner, E. 1988. The art of children's drawing. *Journal of Aesthetic Education* 22: 1, 3–15.

Rosenstiel A., Morison, P., Silverman, J., and Gardner, H. 1978. Critical judgement: A developmental study. *Journal of Aesthetic Education* 12: 95–197.

Rozin, P. 1976. The evolution of intelligence and access to the cognitive unconscious. *Progress in psychobiology and physiological psychology* 6: 245–280.

Saxe, G., and Gearhart, M. (eds.). 1988. *Children's mathematics. New Directions in Child Development*, No. 41.

Schapiro, M. 1953. Style. In S. Tax (ed.). *Anthropology today.* Chicago: University of Chicago Press.

Schon, D. 1983. *The reflective practitioner.* New York: Basic Books.

Scribner, S. 1986. Thinking in action: Some characteristics of practical thought. In R. Sternberg and R. Wagner (eds.), *Practical intelligence.* New York: Cambridge University Press.

Scribner, S., and Cole, M. 1974. *Culture and thought: A psychological introduction.* New York: Wiley.

Scribner, S., and Cole, M. 1981. *The psychology of literacy.* Cambridge: Harvard University Press.

Seefeldt, C. 1979. The effects of a program designed to increase young children's perception of texture. *Studies in Art Education* 20(2): 40–44.

Shweder, R., and LeVine, R. (eds.). 1984. *Culture theory.* New York: Cambridge University Press.

Siegler, R. 1986. *Children's thinking.* Englewood Cliffs, N.J.: Prentice-Hall.

Silbergeld, J. 1987. Chinese painting studies in the West: A state of the field article. *Journal of Asian studies* 46(4): 849–897.

Smith, R. A. 1987. The changing image of art education: Theoretical antecedents of discipline-based art education. *Journal of Aesthetic Education* 21: 3–34.

Stake, R. 1989. Presentation given at Harvard Project Zero on August 4, 1989.

Sternberg, R. J., and Wagner, R. (eds.). 1986. *Practical intelligence*. New York: Cambridge University Press.

Strauss, S. 1982. *U-shaped behavioral growth*. New York: Academic Press.

Sully, J. 1896. *Studies of childhood*. New York: Appleton.

Taunton, M. 1980. The influence of age on preferences for subject matter, realism, and spatial depth in painting reproductions. *Studies in Art Education* 21(3): 40–52.

Tighe, T. 1968. Concept formation and art: Further evidence on the applicability of Walk's technique. *Psychonomic Science* 12: 363–364.

Torrance, E. P. 1986. The nature of creativity as manifested in its testing. In R. Sternberg (ed.), *The nature of creativity*. New York: Cambridge University Press.

Turiel, E. 1969. Developmental processes in the child's moral thinking. In P. Mussen, J. Langer, and M. Covington (eds.), *New directions in developmental psychology*. New York: Holt, Rinehart, and Winston.

Vasari, G. 1976. *Lives of the most eminent painters, sculptors and architects*. (Gaston du C. de Vere, trans.). New York: AMS Press.

Vygotsky, L. 1978. *Mind in society*. Cambridge: Harvard University Press.

Wagner, D., and Stevenson, H. 1982. *Cultural perspectives on child development*. San Francisco: Freeman.

Walk, R.D. 1967. Concept formation and art: Basic experiment and controls. *Psychonomic Science* 9(4): 237–238.

Werner, H. 1948. *The comparative psychology of mental development*. New York: Wiley Inter-science.

Werner, H., and Kaplan, B. 1963. *Symbol formation*. New York: Wiley.

Wilson, B., and Wilson, M. 1977. An iconoclastic view of the imagery sources in the drawings of young people. *Art Education* 30(1): 5–11.

Wilson, B., and Wilson, M. 1979. Figure structure, figure action, and framing in drawings by American and Egyptian children. *Studies in Art Education* 21(1): 36–43.

Wilson, B., and Wilson, M. 1981. The use and uselessness of developmental stages. *Studies in Art Education* 34(5): 4–5.

Winner, E. 1982. *Invented worlds*. Cambridge: Harvard University Press.

Winner, E., Blank, P., Massey, C., and Gardner, H. 1983. Children's sensitivity to aesthetic properties of line drawings. In D. R. Rogers and J. A. Sloboda (eds.), *The acquisition of symbolic skills*. London: Plenum Press.

Wohlwill, J. F. 1985. The Gardner-Winner view of children's visual artistic development: Overview, assessment, and critique. *Visual Arts Research* 11(1): 1–22.

Wohlwill, J. 1988. The role of computer programming in children's production of graphic designs. In G. Forman and P. Pufall (eds.), *Constructivism in the computer age*. Hillsdale, N.J.: Lawrence Erlbaum Associates.

Wohlwill, J. and Wills, S. 1988. Programmed paintings: Elementary school children's computer generated designs. In F. Farley and R. Neperud (eds.), *The foundations of aesthetics, art, and art education*. New York: Praeger.

Wolf, D. 1988/1989. Opening up assessment: Ideas from the arts. *Educational Leadership* 45(4): 24–29.

Wolf, D. 1989. Portfolio assessment: Sampling student work. *Educational Leadership* 46(7): 35–49.

Wollheim, R. 1980. *Art and its objects*. Cambridge: Cambridge University Press.

Wygant, F. 1983. *Art in American schools in the nineteenth century*. Cincinnati: Interwood Press.

Zessoules, R., Wolf, D. and Gardner, H. 1988. A better balance: Arts PROPEL as an alternative to discipline-based art education. In J. Burton, A. Lederman, and P. London (eds.), *Beyond DBAE: The case for multiple visions of art education*. University Council on Art Education.

Zurmuehlen, M. 1977. Teachers' preferences in children's drawings. *Studies in Art Education* 19(1): 52–65.

Howard Gardner

Howard Gardner is a research psychologist in Boston. He investigates human cognitive capacities, particularly those central to the arts, in normal children, gifted children, and brain-damaged adults. He is the author of over two hundred and fifty articles in professional journals and wide-circulation periodicals. Among his ten books are *The Quest for Mind* (1973); *The Shattered Mind* (1975); *Developmental Psychology* (1978); *Art, Mind, and Brain* (1982); *Frames of Mind* (1983); *The Mind's New Science* (1985); and, most recently, *To Open Minds: Chinese Clues to the Dilemma of Contemporary Education* (1989).

At present, he serves as professor of education and co-director of Project Zero at the Harvard Graduate School of Education, as research psychologist at the Boston Veterans Administration Medical Center, and as adjunct professor of neurology at the Boston University School of Medicine. In 1981 he was awarded a MacArthur Prize Fellowship and in 1990 became the first American to receive the University of Louisville Grawemeyer Award in Education.